LONG ISLAND
AND THE
CIVIL WAR

LONG ISLAND
AND THE
CIVIL WAR

*Queens, Nassau and Suffolk Counties
During the War Between the States*

HARRISON HUNT & BILL BLEYER

THE
History
PRESS

Published by The History Press
Charleston, SC 29403
www.historypress.net

Back cover: *The Waiting War* by Mort Künstler. This painting was based on a reenactment of Camp Winfield Scott at Old Bethpage Village Restoration. *©1982 Mort Künstler, Inc.*

First published 2015

Manufactured in the United States

ISBN 978.1.62619.771.8

Library of Congress Control Number: 2015931719

Contents

Acknowledgements

Our thanks to:

- Alexandra Wolfe of the Society for the Preservation of Long Island Antiquities for planting the seed for the authors' collaboration.
- Natalie Naylor and Antonia Petrash for pointing us toward The History Press.
- Whitney Landis and Elizabeth Farry, our helpful editors at The History Press.
- The following for images and research assistance: Oyster Bay town historian John Hammond; Philip Blocklyn and Nicole Menchise, Oyster Bay Historical Society; James McKenna and Robert Hansen, Company H, 119th New York Volunteers Historical Association; Geri Solomon, Victoria Aspinwal and Barbara Guzowski, Long Island Studies Institute at Hofstra University; Toby Kissam, Huntington Historical Society; Geoffrey Fleming, Southold Historical Society; Wendy Polhemus-Annibell and Edward H.L. Smith III, Suffolk County Historical Society; Amy Kasuga Folk, Oysterponds Historical Society; Melanie Cardone-Leathers, Longwood Public Library; Carol Clarke, Local History Collection, the Bryant Library, Roslyn; Erik Huber, Long Island Collection, Queens Borough Public Library; Iris Levin, Nassau County Photo Archives; Carol Stern, Glen Cove Public Library; Chris Olijnyk, William Floyd Estate, Fire Island National Seashore; Herb Strobel, Hallockville

Museum Farm; Tara LaWare and Alexandra Wolfe, Society for the Preservation of Long Island Antiquities; Cynthia Krieg, Freeport Historical Society; local historians Vincent Seyfried, Richard Winsche and David Clemens; Lincoln assassination historian Michael Kaufmann; Roslyn Mabry, Chicago Public Library; and the library staff at United States Army Heritage and Education Center, Carlisle Barracks, Pennsylvania.

- Artist and friend Mort Künstler for the use of his painting on the back cover and his images of the authors.
- And our reviewers/proofreaders: Andy Athanas, Joe Catalano, Bill Finlayson and Linda Hunt.

Introduction

Long Island isn't the first place that comes to mind when thinking about the Civil War. No battles were fought on its soil. The closest the war came was Confederate ships marauding within eight miles of Montauk Point. The nearest battle, the climactic collision between the Union Army of the Potomac and Robert E. Lee's Confederates from the Army of Northern Virginia at the small Pennsylvania crossroads town of Gettysburg, occurred two hundred miles to the southwest. There was little-remembered war-related violence during a draft riot in Jamaica at the same time as the infamous draft riots across the East River in Manhattan in July 1863.

But even though Long Island saw no brother-against-brother conflict, the watershed event in American history affected the lives of every one of those living in current-day Queens, Nassau and Suffolk Counties between 1861 and 1865.

More than 3,000 young men from among the 101,000 people, white and black, living in these areas answered their country's call to preserve the Union by serving in the army or navy. Ten times that number served from among the 280,000 inhabitants of Kings County, including the city of Brooklyn, at Long Island's western end. The percentage of the population in Brooklyn enlisting was three times as high as on Long Island. This was probably a reflection not only of a larger pool of men of service age but also more men who were poor and were willing to serve in the army—including as bounty men/substitutes—and more men who did not have ties to farms and families to keep them at home. Some served with friends in units that

were raised locally; others, because of personal ties, enlisted in regiments organized far from their homes. Several were rewarded with the Medal of Honor. Virtually everyone on Long Island knew a soldier or sailor, making the faraway conflict and its horrendous cost in human lives personal.

The war was also visible in other ways. Some early regiments from New York and New England trained at Long Island camps before heading south. Local businessmen and politicians raised funds to encourage enlistments and to take care of the families of soldiers while they served. Hundreds of Long Island women organized aid societies to help wounded soldiers, and others volunteered at hospitals, where the war was truly brought close to home. Local manufacturers produced war materiel, from medicines to uniforms. And the economic effects of the war years—shortages, higher taxes and disruption of commerce, to name a few—were felt by all.

The Long Island of the Civil War period was vastly different from the island of today. First, at the time, Long Island meant just that: the geographical island stretching from Brooklyn to the points at Orient and Montauk. Greater New York City had not yet been formed (and would not be until 1898), and the cultural distinction between city and suburb that today defines Long Island as Nassau and Suffolk Counties did not exist. The

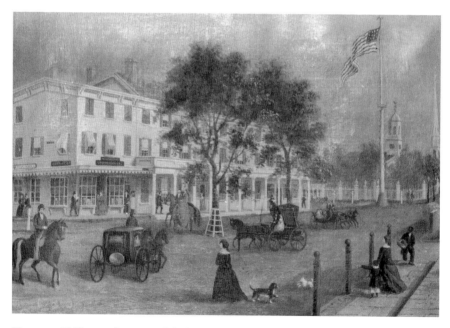

Hempstead Village as it appeared during the Civil War, including the liberty pole raised in 1861. *John Evers, circa 1870. Courtesy of the Nassau County Photo Archives.*

city of Brooklyn was only a portion of Kings County, with the rest still rather bucolic. (While this book touches on Kings, it concentrates on current-day Queens, Nassau and Suffolk Counties, as the story of Brooklyn's role has already been addressed in E.A. Livingston's *Brooklyn and the Civil War*, also published by The History Press.)

Queens County then consisted of six towns: Flushing, Jamaica and Newtown and the three towns of current-day Nassau County, Hempstead, North Hempstead and Oyster Bay. (Nassau did not break away from Queens until 1899.) Suffolk then included nine towns, as Babylon was part of Huntington until 1872.

The story of this area's role in the Civil War is more than just local history; in one easily defined area, it reflects the wartime experience of the entire North in a microcosm. This 110-mile-long, fish-shaped island ran the gamut from the third-largest city in the country—Brooklyn—to sparsely populated rural areas on its two eastern forks. There were thousands of acres of farmland, widespread maritime activity and village centers with businesses, mills and factories. Many communities were served by the growing Long Island Rail Road, which, with coastal sloops and schooners, carried produce from farms to markets in Brooklyn and New York.

The island's population was diverse: it included descendants of Dutch and English families living in the region for two centuries; newer immigrants

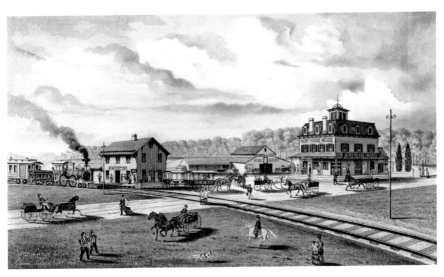

Huntington Station looking much as it did during the Civil War years. *Edward Lange, 1880. Courtesy of the Society for the Preservation of Long Island Antiquities.*

11

from England, Ireland, Germany and elsewhere in Europe; a fairly large African American community, many of whom were descendants of former slaves whose families had lived on Long Island for generations; and Native Americans, members of the Shinnecock, Montaukett, Poospatuck and Matinecock peoples. There were War Democrats and Lincoln Republicans; pro-Union rallies and antiwar sentiment; and thousands of farmers, shopkeepers, baymen, schoolteachers, whalers, factory workers, skilled craftsmen and unskilled laborers who courageously did their part to preserve the Union. All of this is part of the fascinating story of Long Island and the Civil War told in this book.

1
The 1860 Election and the Coming War

The issues that led to the Civil War—the debate over the extension of slavery into the western territories, abolition, states' rights, economic and cultural differences between North and South and the balance of power between them, among others—were raised on Long Island during the tumultuous four-party presidential campaign of 1860, making that a good place to start an examination of the conflict that tore the still-young republic apart.

While slavery was not a burning issue for most Long Islanders before the nominating conventions, that doesn't mean some inhabitants weren't thinking about it—particularly free blacks, escaped slaves, Quakers and other abolitionists determined to go beyond stopping the spread of slavery and eradicate the "peculiar institution" everywhere it existed. Despite the risk of prison for violating the Fugitive Slave Act, they served as conductors on the Underground Railroad, sheltering escaped slaves in Newtown and College Point in northwestern Queens, Westbury, Jericho, Setauket and other communities. While Long Island may seem like an out-of-the-way stop on the way to freedom, its many ports made it a good place for escaping slaves to take boats to Westchester, New England or Canada.

Some fugitive slaves remained on Long Island, hiding in plain sight in free black communities such as The Brush, founded by Quakers in Jerusalem, now part of North Bellmore and Wantagh. Among those who stayed were Peter Johnson, who became a farm laborer in Jericho, and John Wheeler, who settled into the black community in Westbury and became caretaker of

the Friends cemetery there. His escape from Virginia by hiding in the Dismal Swamp was so traumatic that he would not discuss it, telling people that he had "disremembered" it.[1]

Few Long Islanders were active abolitionists, and at least one resident, William Jagger of Bridgehampton, actively endorsed slavery. Following an 1855 trip through several slave states, Jagger wrote a book in which he argued that the slaves "are as happy as the white people are North or South, and do not labor as hard as the white people do in the Free States…The slaves had a plenty to eat, plenty of clothes to wear, were well treated…and, when sick, were taken good care of."[2]

Whatever their feelings on bondage, island residents would have a hard time ignoring the issue once the presidential campaigns began. The acrimony over extending slavery to the western territories ruptured the Democratic Party into Northern and Southern factions. Senator Stephen A. Douglas of Illinois was considered a traitor by the Southern delegates for supporting "popular sovereignty," which permitted territories to choose between being slave or free states when they entered the Union. The Southerners walked out of the Democratic Party's convention in April, allowing the nomination of Douglas with Herschel V. Johnson of Georgia for vice president. The splinter delegates held their own convention five days later and nominated John C. Breckinridge of Kentucky, the vice president of the United States, to lead the National Democratic Party slate with Joseph Lane of Oregon as his running mate. Meanwhile, delegates for a new Constitutional Union Party chose wealthy slave owner John C. Bell of Tennessee for president and Edward Everett of Massachusetts for vice president, running on a platform that called for ignoring the issue of slavery. The most radical approach to that issue was the Republican Party's. Meeting in May, its delegates adopted a platform barring any expansion of slavery and nominated Abraham Lincoln of Illinois with Hannibal Hamlin of Maine as the vice presidential candidate.

All four candidates gained some support from the newspapers serving Long Island. The daily *Brooklyn Eagle* hedged its bets, carrying advertisements for Lincoln, Douglas and Breckinridge, while ads for all four candidates appeared in various weeklies. The Republicans and their allies made it clear the party would preserve the Union at all costs, while the other three candidates contended a Republican victory would dismantle the nation.

Like New York City, Long Island had been historically Democratic territory. But by 1860, the Republicans had made some inroads because of the party's platform to contain slavery and resentment over what was seen as the South's disproportionate control over the federal government.

Local Republicans and the newspapers that supported them hailed Lincoln's nomination. "There is no denying the fact—the Republicans have made a strong nomination," the *Glen Cove Gazette* declared. Lincoln "is conservative in his political views, a representative man of the country, self made and having about him the elements of a popularity that have already set the North West in a blaze of enthusiasm." Republican editors correctly predicted the outcome of the four-way race, while their Democratic counterparts were swayed by wishful thinking. The *Long-Islander* opined that with the Democrats "split in twain" between Douglas and Breckinridge, "present indications are that it will be some time…before either of them will reach the White House." But the *Suffolk Democrat* declared, "Lincoln has neither the talents, the popularity nor the prestige of former victories to make him even third best in this contest."[3]

Soon, meetings to endorse the nominations were being held. A Lincoln and Hamlin Central Club met in East Norwich in mid-June, and on the sixteenth, "a large and enthusiastic meeting" of Queens Republicans was held in Hempstead, resolving that "we have a standard bearer fresh from the people, honest, able and true, in whose hands the Administration of the federal government will be restored to its original purity and made an honor rather than a reproach to the Republic."[4]

By midsummer, the politicking was in high gear. In July, national Republican leader and *New York Tribune* editor Horace Greeley spoke in Glen Cove while the village's Democrats met to form a Douglas and Johnson Club. In August, the "Friends of Breckinridge and Lane" held a meeting in Flushing that attracted "quite a respectable" turnout. Soon after, "the Republicans of Astoria…were out in force to ratify the nomination of Lincoln and Hamlin," and "the Douglas Democracy of Flushing held a large meeting at the Flushing Hotel." In Glen Cove, the *Gazette* reported that "the young men of this village have taken the preliminary steps to organize themselves into a Wide Awake Club [as were] the young men of Oysterbay and East Norwich." The Wide Awakes were Republican campaign organizations that held torchlight parades with members in uniform carrying banners supporting Lincoln and Hamlin. Wide Awake Clubs were soon active in many Long Island communities, including Glen Cove, Roslyn, Hempstead, Jamaica and the hamlets along the North Fork; the Southold Historical Society owns a rare banner, hat and torch used in parades there.[5]

Not to be outdone, a National Union Club was formed in Farmingdale, and the Democrats had meetings in Glen Cove and East Norwich and organized "Minute Man" groups in response to the Wide Awakes. One of their parades

in Jamaica was described as "a beautiful sight…numbering about 90 in uniforms." In the week before the election, a Democratic march in Flushing attracted up to 1,200 men and "was larger in proportion to the population than that on Tuesday night in the City of New York. The procession was heartily cheered," and fireworks were set off. There were rallies drawing more than 200 each in Freeport, Far Rockaway and Patchogue and another in Springfield with 100 Jamaica Minute Men and 60 Hempstead Minute Men on hand. A story about a Whitestone rally noted that there were 30 mechanics and workingmen, and "in the line of procession was to be seen a Blacksmith's forge on a wagon drawn by horses…Farmers also with their wagons decorated with sheaves of Wheat, Oats, Corn, etc. which added largely to the interest of the occasion."[6]

As the election neared, the editorial rhetoric became nastier. "Are the citizens of New York ready to introduce the Negro into their…assemblies and their political conventions on a social and civil equality with themselves?" an editorial in the *Corrector* asked, focusing on race to drive readers to vote Democratic. "There is nothing common between the Anglo-Saxon and the African races. Their character, their habits and their tastes differ entirely." The *Long-Islander* declared Douglas "spits on the adopted citizen," and Breckinridge was "the candidate of the secessionists." The paper argued "the election of Lincoln will never dissolve the Union," a contention seconded by the *Hempstead Inquirer*, which stated that however the vote went, "the great Republic will still live." The *Corrector* was still stridently predicting defeat for Lincoln, stating that the Republicans "in this State…already begin to cry sour grapes, in view of the crushing defeat that awaits them."[7]

In its Election Day issue, November 6, the *Long Island Democrat* reminded readers to vote in

> *the most important election ever held in this country…Remember that New York is the battlefield in this contest, and upon the result of our action may depend the issue of peace or war…Remember that the Republican Party is sectional in organization, fanatical in principle, and dangerous to the peace of the country…Every Union man will go against the extension of the suffrage to the colored race. It will be sustained by the Black Republicans and their candidates.*

When the votes were tallied, Breckinridge had carried all of the Southern states, but the divided Democrats had no chance of winning the election. The electoral vote was 180 for Lincoln, 72 for Breckinridge, 39 for Bell and

12 for Douglas. The Democrats—whose two factions agreed to combine for a fusion vote total in the election—carried Queens by more than 600 with the strongest support in the western towns. The Republicans won Hempstead by 414 votes and squeaked by in North Hempstead by 18. Lincoln had a majority of about 240 votes in Suffolk out of 7,231 cast, and the party won New York State by 44,700 votes. On Shelter Island, the Republicans won by more than 3 to 1; the party also took Southold comfortably, as well as Southampton, Riverhead, Islip and East Hampton by narrow margins. The Democrats prevailed in Brookhaven and Smithtown and claimed victory in Huntington in a close race.[8]

Even though Lincoln did not win Huntington, Republicans there were overjoyed at the outcome in the county and beyond. "The streets were aflame with bonfires, and resonant with the music and shouting, with a demonstration by the Huntington Juvenile Wide Awakes and a meeting of the Friends of Freedom and the Union." In Sag Harbor—a village divided between the towns of Southampton and East Hampton, both of which voted Republican—the *Corrector* grumbled that Lincoln was "the chosen standard bearer, of a party containing dangerous elements, and controlled in a great measure by fanatical extreme leaders." But the pro-Republican *Sag Harbor Express* crowed: "For the first time the Town of East Hampton has given a majority against the Democratic ticket…Who says the world don't move?" The *Hempstead Inquirer* commented that "we can hardly say that we are sorry at this result, for so much has been said about disunion, secession, etc. in case of the election of a Republican to the highest office in the Republic, we are quite willing to have it tested, whether the Union is held together by so frail a tenure."[9]

The political ramifications of the election came quickly. Even before Lincoln's inauguration, Southern states began seceding, seeing the Republicans' stand against extending slavery into the territories as the final straw. They recognized that denying slavery in the territories meant that there would be no additional slave states, with the balance of power between North and South in the Senate inexorably shifting to the North, a situation they could not accept. "The South Carolina Legislature have passed resolutions toward secession," the *Inquirer* warned, "and fanatical leaders are using all of their influence to array a few states against the Union. How a course, so suicidal, can be seriously entertained by any sane mind is passing strange."

Many blamed secession on misunderstandings about slavery, as reflected in a *Flushing Journal* editorial entitled "America for the Americans—Not for the Africans": "A great and generous proportion of our country is ready to fly from the Federal Government…We sorrow all the more because they are

quite mistaken in the nature of their complaint…They persuade themselves that…we want to place the colored race on a level with the pure Anglo-Saxon…America is for American free men, not for slaves."[10]

As 1861 opened and war loomed, the tone of Long Islanders and their newspapers became more patriotic and more caustic toward the Southern states. The *Long-Islander* roared that "the slaveocracy…having…in a fair fight, been beaten…like a cowardly unprincipled boy, turn and attempt to repudiate the Union and the Constitution." A second editorial showed the paper's continuing foresight and the region's growing fear of war:

> *The secession movement appears to be gaining strength every day. Florida and Mississippi have already followed the example of South Carolina, and the hour seems to be fast hastening when the whole of the Southern States will be in the hands of an infuriated mob. We predict the day not far distant when the Federal Government will be called upon to send volunteers to protect them from the servile insurrection in their own borders.*

Meanwhile, many Democrats in the New York area were transforming into "War Democrats," backing away from their strident pro-Southern posture and growing more insistent in their desire to preserve the Union.

The *Corrector* reflected this trend, editorializing about "the 'irrepressible conflict' forced upon the country by the wily and designing politicians at the North and the South…The whole question of the times is will the North agree to that settlement on a basis just and equitable to all parts of the Confederacy." Republicans, however, continued to speak forcefully against compromise: "The founders of our Republican Confederacy made but one mistake, and that was in compromising at all with Slavery…Let the abhorred thing, Slavery, rest where it is, but may be scorned of man and the curse of God smite its every advancing step on the domain of human Freedom."[11]

With the Southern states equally unwilling to compromise, the secession crisis spiraled. The *Corrector* lamented: "The Union as it was is lost. Seven states, left to unrestrained and hasty action, have seceded, and are now enjoying a Provisional Government of their own. 'The Confederated States of America' are no myth."[12]

But the *Long-Islander* on March 8 still saw a reason for hope: "Abraham Lincoln has gone up to the White House. We have a president, and a Government, once more."

Lincoln and that government would have only five weeks to prepare before they would find themselves at war.

WILLIAM CULLEN BRYANT: POET, NEWSPAPER EDITOR AND LINCOLN SUPPORTER

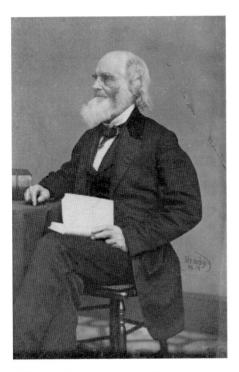

William Cullen Bryant, circa 1860. *From the collection of Linda and Harrison Hunt.*

Roslyn resident William Cullen Bryant was one of the most influential newspaper editors of the Civil War era and Long Island's closest tie with Abraham Lincoln.

Born in Cummington, Massachusetts, on November 3, 1794, Bryant was given a good classical education by his family, and while a boy, he showed a talent for writing. His poem "Thanatopsis," a meditation on nature and death published in 1817, was the first poem by an American to gain international acclaim. "To a Waterfowl," printed the next year, is regarded by many scholars as the finest short poem in English.

After moving to New York in 1825, Bryant was hired the following year as the acting editor of the *New York Evening Post*. He was soon made editor and part owner of the *Post*, a job he held for the rest of his life. Under his leadership, the *Post* became a major newspaper in New York, espousing such causes as the elimination of slavery. By 1843, Bryant and the *Post* had done well enough that he was able to purchase a country home in Roslyn, naming it Cedarmere after the cedar trees that ringed the mere, or lake, on the property.

Bryant's stand against slavery led him to be one of the founders of the New York State Republican Party and one of Abraham Lincoln's earliest supporters in the state. Bryant's four brothers had moved to Illinois in the 1830s and knew Lincoln before he had become nationally famous. They shared William's views about slavery—John Howard Bryant used his house as an Underground Railroad stop—and brought Lincoln to William's attention. As a result, when Lincoln came to New York City to

make his famous Cooper Union Address in February 1860 while seeking the Republican presidential nomination, he was introduced by the editor. Of the occasion, Lincoln stated, "It is worth a visit from Springfield, Illinois, to New York to make the acquaintance of such a man as William Cullen Bryant."

Bryant and the *Post* actively campaigned for Lincoln in 1860. In appreciation, Bryant's name appeared on state ballots as an elector for Lincoln. The editor continued to advise the president during his administration. He visited Lincoln at the White House in August 1862 to urge him to tie the war effort to abolition, helping to solidify the president's decision to issue the Emancipation Proclamation the following month.

The poet shared the nation's shock at Lincoln's assassination on April 15, 1865. He wrote "The Death of Lincoln" for the memorial meeting held in Union Square, New York, on April 25. The piece includes the moving lines

> *Thy task is done; the bond are free:*
> *We bear thee to an honored grave,*
> *Whose proudest monument shall be*
> *The broken fetters of the slave.*

In the years that followed, William Cullen Bryant supported freedmen's rights and Reconstruction. He died on June 12, 1878, and is buried in Roslyn Cemetery near his beloved Cedarmere.[13]

2

Reaction to War

Following the Confederate attack on Fort Sumter on April 12, 1861, political disagreements were largely laid aside amid a general outpouring of support for the Union across Long Island. "War Upon Us" trumpeted the headline of the *Glen Cove Gazette* on April 20.

> *The past has been a most exciting week…the fall of Sumter and the inauguration of Civil War! More people have hoped and prayed that this cup of bitterness might pass from them, that our political troubles would find a peaceful solution, and that we might escape this most terrible of national calamities…Deploring the issue forced upon them, and with a throb of deepest regret, the loyal States…spring to arms with a unanimity and energy worthy of their revolutionary renown—of the cause of which they are now to battle—THE UNION, THE CONSTITUTION AND THE ENFORCEMENT OF THE LAWS!*

In Huntington, the *Long-Islander* raged with abolitionist fervor:

> *War has at length come—not at the desire or seeking of the loyal Free States, but forced upon them, and upon all loyal American people, by the insolent and insatiate Slave power of this Republic…The shameless rebels against the Union and the Constitution have begun the conflict, and may God have mercy on their souls when the strong arm of an aroused and united people shall be fairly lifted to strike treason to the dust.[14]*

While some people shared the antislavery views of the *Long-Islander*'s editor, preserving the Union established by the founding fathers was the issue around which support for the war crystallized on the island in the spring of 1861. Even newspapers that previously had been conciliatory toward the South took a firm stance against secession. "If you cannot at this crisis forget Party and show yourself a Patriot, we sincerely pity your miserable condition," the Sag Harbor *Corrector* declared. "This is no time for party bickerings. There are but two parties: one is for the country, the other against it. One will fight for the Old Flag and the Union which it symbolizes; the other would trample that banner underfoot and dissolve that Union."[15]

This patriotic fervor was reflected in the rallies held across Long Island following the onset of the war. Within days, mass meetings were organized in Jamaica, Flushing, Newtown, Hempstead and Oyster Bay in Queens and Huntington, Riverhead, Sag Harbor, Hauppauge and Northport in Suffolk. These were soon followed by additional gatherings in Cold Spring Harbor, East Hampton, Manhasset, Little Neck and other communities large and small. The meetings typically included resolutions in support of the Union, invocations and patriotic orations. These addresses were usually delivered by prominent local residents: ministers, newspaper editors and politicians such as David Floyd-Jones of Massapequa. Floyd-Jones served as New York secretary of state from 1860 to 1861 and as lieutenant governor from 1864 to 1865. Although he was a Democrat, like most of Long Island's elected officials during the Civil War period, he was a staunch Unionist and strongly supported the war effort. Floyd-Jones and the other orators at these meetings called on citizens to defend the sacred union of the states and castigated the South for attempting to destroy what the Patriots of the Revolution had created. John J. Armstrong's Fourth of July address in Jamaica in 1861 was typical of these speeches:

> *Do you ask me what your duty is now? You are bound by every principle of justice to sustain…the government, and defend with unwavering fidelity the Constitution. By every means in your power, at every hazard and by every sacrifice this Union must be preserved…This Union cemented by the blood of patriots…must not be sacrificed to the designing motives and ambitious heart of those who prefer to destroy it, if they cannot rule.*[16]

Some addresses were naïvely optimistic about the length of the struggle the nation was facing. It was reported that one man at a meeting in East Norwich asserted that all the North needed to do was send a couple of old ladies with brooms down south and the Rebels would go running.

In addition to speeches, the more elaborate rallies of 1861 often included the raising of a liberty pole, a tall flagpole bearing the stars and stripes. Patriotic enthusiasm led to a friendly rivalry among some villages in current-day Nassau County. After Mineola raised a 76-foot pole, Farmingdale put one up as well, and Freeport erected one 90 feet tall. "Not to be outdone Hempstead put up a 116-foot high pole topped by a large golden eagle. With that, the contest for the tallest pole waned." The citizens of Greenport, East Hampton, Sag Harbor, Bay Shore, Setauket, Huntington, Glen Cove and Merrick proudly raised flagpoles as well.[17]

Churches, too, got swept up in the patriotic fervor. Some with tall steeples, like the Presbyterian church in Sag Harbor (better known as Old Whalers Church) and the Methodist church in Hempstead, raised American flags to their highest points to show their support for the war effort. Pastors across Long Island, including the Reverend MacDougall of Freeport, Stephen Mershon of East Hampton and Epher Whitaker of Southold, gave patriotic sermons. After the surrender of Fort Sumter, the Reverend Hiram Crozier of Huntington preached wearing a red, white and blue rosette on his breast. Edward Hopper, pastor of Old Whalers Church, even wrote a pro-Union song, to the tune of *My Country 'Tis Of Thee*:

Flag of the Brave and Free,
Flag of Our Liberty,
Of thee we sing!
Flag of our father's pride;
With their pure hearts-blood dyed.
When fighting side by side
Our pledge we bring!
We love each tattered rag
Of that old war-rent flag
Of Liberty!
Flag of great Washington!
Flag of brave Anderson!
Flag of each mother's son
Who dare be free!

The Anderson referred to is Major Robert Anderson, commander of the Union garrison at Sumter.[18]

Some clergy went beyond tending their home flocks and volunteered as chaplains in the army. Among them were William Gilder Sr. of

Flushing, Smith Gammage of Patchogue, Alanson Haines of Amagansett and Albert Skidmore of Setauket. These men saw to the spiritual and emotional needs of the soldiers in their units, counseling the men, notifying their families when they were wounded or sick and leading services in the field, such as that described by Private Stephen Thatford of the Fourteenth Brooklyn Regiment:

We go to church here in a different manner than you do in Gowanus. We all fall into line and march off into the woods, where we form a hollow square…with no roof but the trees. Our chaplain being in the center, he requested all who were used to singing to step out and form a sort of choir… They sang…with earnest voices, and it fairly made the woods ring.[19]

Not to be outdone by the men of the cloth, a number of Long Island physicians volunteered to do their part as well. Dr. John Ordronaux of Roslyn, an early professor of legal jurisprudence (as forensic medicine was then known), gave physicals to recruits and authored two significant manuals for the use of army doctors. *Hints on the Preservation of Health in Armies; For the Use of Volunteer Officers and Soldiers*, printed in 1861, was the first manual of military hygiene written in America and particularly valuable to officers who had been given little or no training in maintaining soldier health. His second volume, *Manual of Instructions for Military Surgeons; On the Examinations of Recruits and Discharge of Soldiers*, was published in 1863, just in time to be used for physicals during the newly instituted draft. Several Long Island doctors passed a fairly rigorous examination and were able to enlist as army surgeons, tending to the wounded and sick as best they could in the age before knowledge of germs and sterilization. Among them were William Strew of Oyster Bay, Josiah Culver of East Hampton, John Walker of Babylon and George Wright of Newtown. At least one, Dr. Edgar Jackson of Wantagh, died in service, of exposure and overwork.[20]

While there was tremendous support for the war effort on Long Island in 1861, it was not universal; there were a number of Southern sympathizers scattered across the area. These "Copperheads," as they were known after the venomous snake, found little support in most of Queens and Suffolk. A visitor from Brooklyn spouting pro-Southern opinions in Orient early in the war awoke to find an effigy hanging outside his inn bearing the sign, "H.T. Tabor of Brooklyn—The Doom of Traitors." Forty citizens of Northport, declaring, "We are determined to put down secession and traitors," signed a pledge "not to aid, assist, or patronize any merchant, hotel keeper, mechanic,

or any treasonably disposed person." When the pro-Southern members of the Episcopal church in Islip threatened to remove an American flag from its steeple, "they were quietly told that if they tore that flag down the church would be leveled to the ground." The pastor of the Presbyterian church in Southampton, the Reverend William N. Cleveland, brother of future president Grover Cleveland, had to leave town after delivering sermons in support of slavery and the South. An antiwar rally in Newtown was co-opted by Unionists, who paraded a coffin bearing the inscription, "Secession died at Newtown August 29, 1861." "The crowd…gave thrice-repeated cheers for the Union and the Constitution and hurled anathemas against treason and traitors."[21]

The most colorful incident of antiwar sentiment took place in Plainview in August 1861, when farmer Jerome Lobdell raised a "Secessionist flag," bearing eleven stars for the Confederate states and the legend "State Rights," on a flagpole in front of his house. After refusing his neighbors' demands to remove the banner, a mob including some members of the Oyster Bay militia company ripped down the offending flag. When Lobdell subsequently refused to fly the stars and stripes, a second group of neighbors armed with clubs and guns chopped down the flagpole.[22]

Lobdell might have been more welcome on Long Island's North Fork, which was a hotbed of pro-Southern sentiment. The reasons for this are not clear; it may have been the disruption of trade in its seaport communities or a conservatism born of the area's isolation, but whatever the cause, it was widespread. Henry Reeves, editor of Greenport's anti-administration newspaper the *Watchman,* was so virulent in his denunciation of the war that he was accused of sedition and seized in September 1861. After being held for a month in Fort Lafayette in New York Harbor, where those suspected of treason were incarcerated, he was finally released and continued his screeds for the rest of the war. In Northville, pro-Union man George W. Hallock was tipped off not to take his usual route to a meeting one night because some Copperheads were planning to attack him.[23]

A few Long Islanders went even further in their support of the South, casting their lot with the Confederacy. John H. Hobart, a former Sag Harbor resident who had moved to Vicksburg, Mississippi, wrote the editor of the Sag Harbor *Corrector* on May 11 to cancel his subscription, telling the publisher to "keep your infamous abolition newspaper at home. You…can go to Hell. I belong to the Mississippi 7th Regiment and shall be happy to meet [you and your kind] on the Battle Field." Such deep-seated feelings divided at least one local family: Smithtown resident Henry Smith received a letter from his

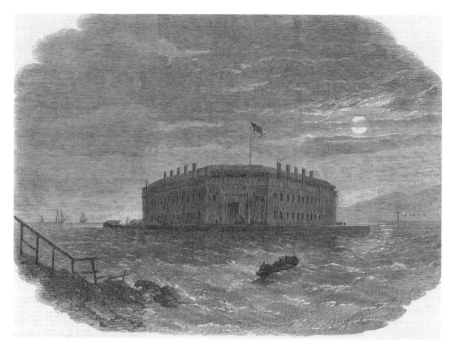

Fort Lafayette, where traitors and high-ranking Confederate prisoners were held. *From the collection of Linda Hunt.*

mother, who was living in Mississippi with his stepfather, declaring, "As for myself, I am Southern all over, there's not a drop of Northern blood in my body, and I am sorry there is any in yours."[24]

Southern sympathizers notwithstanding, support for the Union remained strong on Long Island, even after the Union defeat at the First Battle of Bull Run on July 21 and for the years that followed. This was seen in the enlistments and homefront activities covered in subsequent chapters of this book and in the reception local residents gave to the soldiers in the several training camps established in Queens County during the war. Among these was the camp of the Forty-second New York Volunteers, the famed "Tammany Regiment." This unit, sponsored by the Tammany Hall Democrats of New York City, was quartered in Great Neck from the time it was organized in June 1861 until mid-July.

Surprisingly, the Tammany Regiment was one of the few New York units that trained locally. Most of the troops in Long Island camps were from New England, sent here for some basic training before being sent south. The first was the Second Maine Regiment, which arrived at Camp Morgan on Willets

Point (the current site of Fort Totten) in early May 1861. Three months later, the Eighth Maine and Third New Hampshire Regiments were sent to Camp Winfield Scott in Mineola. The camp was located on the plains north of the village of Hempstead, approximately where the Nassau County courts complex is located on Washington Avenue. *The Waiting War*, a depiction of the men of Camp Scott by Long Island artist Mort Künstler, is illustrated on the back cover of this book. During the few weeks they were there, the men of the Third New Hampshire made a particularly good impression on the local residents. On at least one occasion, they paraded their band to Hempstead and gave a concert in appreciation for the warm welcome they had been given. The program of "Patriotic and sentimental airs" was described by the *Queens County Sentinel* as "executed with artistic skill and fine taste."[25]

About the same time, the Eighth Connecticut Infantry set up Camp Buckingham about a mile west of Jamaica. The soldiers hosted visits by local men and women, worshiped at area churches and soon became particular favorites of the people of Jamaica, who donated a flag to the regiment in October. When one of the soldiers fell ill and could not accompany the unit when it left the village, some residents took him into their home for nursing. When he subsequently died, the citizens provided a plot for him in the Roman Catholic cemetery.

Over the next year, a number of regiments set up camp at the racecourses

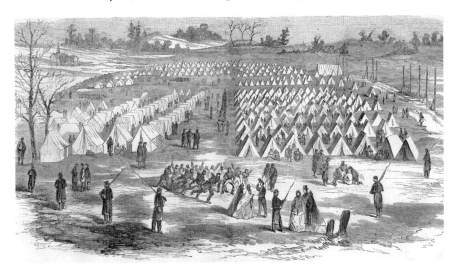

Encampment on the Union Course Race Track, Queens. Harper's Weekly, *December 13, 1862. From the collection of Bill Bleyer.*

that dotted Queens County; their flat, open spaces made perfect training grounds. General Daniel Sickles's Excelsior Brigade was at the Fashion Course in current-day Corona in 1861. The following year, the Union Course Race Track in Woodhaven hosted New Hampshire and Massachusetts troops gathered for General Nathaniel Banks's forthcoming expedition to Louisiana, while Connecticut and upstate New York units awaiting the onset of campaign were housed at the nearby Centerville Race Course.

These training camps gave local boys a glimpse at army life and helped spur the hundreds of enlistments that occurred in the first months of the war.

THE REVOLT OF CAPTAIN CRESTO'S COMPANY

Confusion at a training camp on Willets Point in Queens resulted in one of the few incidents of war-related bloodshed on Long Island. It occurred

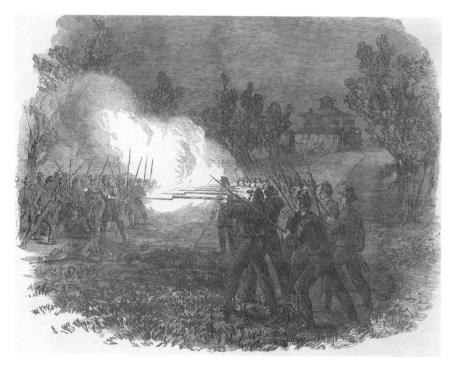

Revolt of Captain Cresto's Company at Willets Point. *From* The Soldier in Our Civil War.

when a company of infantry under the command of a Captain Cresto was encamped there in September 1861 as part of the New York Rifles regiment then being formed. Cresto, not accepting that his unit was bound to service with the Rifles, decided to take his men out of camp so they could join a regiment more to his liking. He attempted to leave around 11:00 p.m. on September 9 but was stopped by the guard, which had been tipped off about his plans. Words were exchanged, and one of Cresto's sergeants accidentally discharged his pistol into the air. Thinking they were being attacked, the guard opened fire on Cresto's men, killing two and wounding four, one mortally. Cresto was arrested the next day, but his fate is unknown. His command was eventually incorporated into the Fifty-first New York Volunteers.[26]

3

Long Islanders and Their Military Units

The commitment shared by the young men of Long Island to preserve the Union can be clearly seen in the thousands of enlistments during the Civil War.

Henry W. Prince, a farm boy from Southold, listened to the oration of an army recruiter in the summer of 1862 and, like dozens of his neighbors, signed up to bind together the nation envisioned by the founding fathers. "I enlisted to help save our country," Prince, of Company H of the 127th New York Volunteer Infantry Regiment, wrote home the next spring.[27]

It is impossible to determine how many Long Islanders joined Prince in the fight to subdue the Confederacy. Lists of servicemen printed in local newspapers or compiled by towns during the war are incomplete. At the end of the conflict, the state required each town to document every soldier and sailor who served, but those records are missing for several municipalities. In addition, most rosters include men from outside the local jurisdictions who received bounties to fill that town's quotas for supplying soldiers.

The records that do exist show that more than three thousand men from among the approximately eighteen thousand of service age (eighteen to forty-five) in Queens and Suffolk did serve. It's estimated that a third of the voters in Flushing and Eden Vale (now Brentwood) volunteered. The young men of Oyster Bay responded enthusiastically to Lincoln's call, with almost six hundred seeing combat. Enlistment rallies were common early in the war, usually featuring an officer or prominent politician giving a patriotic

speech, often escorted by soldiers showing off their new uniforms with a band to stir up some fervor.[28]

The soldiers came from a wide range of occupations reflecting the common livelihoods on Long Island in the period. Farmers, day laborers and those making their living from the sea as sailors, fishermen and boatmen were the most numerous. Other recruits, as seen in a sampling from the Riverhead town list of men eligible for service in 1862, were employed as ambrotypists, blacksmiths, butchers, carpenters, carriage makers, clerks, druggists, harness makers, masons, millers, printers, stage drivers, stonecutters, storekeepers, tailors, tinsmiths, watchmakers and wheelwrights.

Like Henry Prince, most who enlisted did so from an intense sense of patriotism. A soldier from the Seventy-fourth New York Infantry identified only as "Albert" of Hempstead made that point with a flourish in a letter in the *Hempstead Inquirer* on February 22, 1862:

> *The good cause which we are engaged…is…to protect and hand down to posterity unimpaired those blessings that we have enjoyed for years…We are willing to endure hardships and privations, if need be to spill the last drop of our blood for the Glorious Old Stars and Stripes…Shall we…tamely submit to the yoke of bondage, to the galling chains of Slavery, or bow the knee to the aristocratic-oligarchy of the South? Forbid it, "Almighty God."*

Others volunteered because they, like Albert, felt the South had been forcing its way of life on the North for too long. Groups of relatives and friends often signed up to share the camaraderie and adventure and prove they weren't cowards. Some men were undoubtedly taken in by recruiting ads such as one for the Forty-eighth New York Infantry, offering "as an inducement, the pleasure of spending the winter in Savannah," where they were to garrison a fort. And others, like Edwin Worthington of Suffolk, felt, "I could find nothing to do anywhere so…enlisted."[29]

Some, though, enlisted because they viewed the conflict as a means of abolishing the horrors of slavery. One soldier in the Forty-eighth New York who identified himself only as "C" wrote, "We are an army of freedom… Who does not admit slavery to be the cause of this war." Many of those who enlisted over abolition were from Quaker families, including Jericho native John Ketcham, Benjamin Willis of Roslyn and Daniel Lewis Downing of Oyster Bay. Although pacifism is a central belief of the Society of Friends, during the Civil War, the moral evil of slavery was seen to override the moral evil of warfare, and those who fought were not ostracized by their Quaker

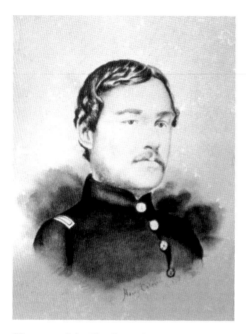

Lieutenant John Ketcham, Company M, Fourth New York Cavalry, circa 1861. *Courtesy of the Nassau County Photo Archives.*

meetings but honored for their service. Both John Ketcham and his younger brother Edward died fighting for what they believed in and were memorialized as the "Fighting Quakers."[30]

When war erupted in April 1861, the regular U.S. Army was too small to deal with the conflict, so the Union relied on volunteer units raised by the states for most of the fighting. There were a few Long Islanders who served as career soldiers in the regular army, including Brigadier General Alfred Gibbs of Astoria and DeLancey Floyd-Jones of South Oyster Bay, now Massapequa. Floyd-Jones, a cousin of wartime New York lieutenant governor David Floyd-Jones, graduated from West Point in 1846 and saw combat in the Mexican War and California before being commissioned a major of the Eleventh U.S. Infantry in 1861.

But most men fought with volunteer units. The state usually recruited by companies of one hundred men or regiments of ten companies or one thousand men, although in reality, many were shorthanded. The local militias—the Fifteenth Regiment in Queens and the Sixteenth Regiment in Suffolk—were unable to recruit sufficient men to serve as volunteer regiments, so local residents were forced to enlist in other units. This situation caused a good deal of embarrassment to community leaders. The *Corrector* in Sag Harbor fumed that "Suffolk county, with her forty-four thousand inhabitants, in this hour of the public danger, where everywhere else men are rushing to arms in defense of their country, [remains] without a regiment…Wake up men of Suffolk ere the finger of scorn is uplifted by your Sister Counties!" In Queens, the *Flushing Journal* bemoaned that "everything connected with the Fifteenth regiment went up like a rocket and came down like a stick."[31]

Early on, some joined the Ninth, Thirteenth and Seventy-first New York State Militia Regiments, which were called up for only ninety days when no

one expected the war to last long. Later, when the horrific casualty counts at Bull Run and Shiloh showed the struggle would be long and bloody, Long Islanders volunteered or were drafted into regiments usually mustered in for three years. White soldiers served in significant numbers in at least seventeen state regiments of infantry, cavalry and artillery discussed below; African Americans served with units of United States Colored Troops, which are discussed in Chapter 5.

Surprisingly, a number of Queens and Suffolk men enlisted in regiments raised elsewhere in the state, and some served in units from New Jersey, Connecticut, Rhode Island and Massachusetts, either because of personal ties or geography. For some it was easier to cross Long Island Sound when travel by water was common rather than take the Long Island Rail Road, stagecoach or other method of transportation into Brooklyn or Manhattan to enlist.

Sixteen churchgoers from Amagansett followed their pastor, the Reverend Alanson Haines, to the Fifteenth New Jersey Infantry when he signed up as its chaplain. Other Long Islanders enlisted in the Tenth Connecticut, Eighth Rhode Island and Forty-seventh Massachusetts. Several young men from Glen Cove joined the Fifth Connecticut, and John Pollitz of Roslyn became a soldier in the Forty-fourth Massachusetts. Pollitz had been the Sunday school superintendent at Trinity Episcopal Church in Roslyn, and he donated his army pay to purchase a bell for the church. The bell was tolled for the first time at the funeral of the nineteen-year-old soldier, who died of camp fever in January 1863.[32]

Benjamin Laws Homan of Patchogue enrolled in the Ninth New Jersey Infantry. He was captured at Bermuda Hundred, Virginia, on May 16, 1864, and sent to the infamous prison camp at Andersonville, Georgia. Whether to keep up their spirits or his own, Homan wrote his parents on June 2 that "we fare well here we get plenty to eat and see good times all our boys are well and in good spirits we have a large camp with a brook running through the middle." Thanks to contamination of that brook by human waste, little food and little shelter, Homan died on February 25, 1865, shortly before the war ended.[33]

Whatever their regiment, Long Island's soldiers, many away from home for the first time, seemed in almost universal agreement on certain aspects of army life: there was plenty of monotony and discomfort in camp, with no privacy and little healthful food, with the result that more men were brought down by sickness than Confederate bullets. So most, understandably, were homesick, although some welcomed and thrived in the novelty, adventure and camaraderie.

THE REGIMENTS[34]

MILITIA

Most militia units were only called up for short-term service. Local men volunteered in two of those regiments, the Thirteenth Brooklyn and the Seventy-first New York. Both were called up three times during the rebellion.

Thirteenth Brooklyn

The regiment was one of the first in the North to answer President Lincoln's call for troops to protect Washington, D.C., embarking from Brooklyn on April 13, 1861, with some Queens men in its ranks. It served at Annapolis and Baltimore, Maryland, for three months and was mustered out on August 6, 1861, at Brooklyn. On May 26, 1862, the regiment was again ordered to the defense of Washington for three months, serving at Suffolk, Virginia, until September 12, 1862. Its third tour of duty was during the Gettysburg Campaign in 1863, when it was ordered to protect Harrisburg, Pennsylvania. It served from June 20 until July 21. Among its soldiers was Andrew Jackson Whitman, one of poet Walt Whitman's younger brothers.

Seventy-first New York

On April 21, 1861, only nine days after the firing on Fort Sumter, the unit's 950 men, including some from Sag Harbor, departed for Washington. The Seventy-first was at Bull Run on July 21, when 10 were killed, 40 wounded and 12 captured. Its second service, from May 28 until September 2, 1862, was also in defense of Washington. The third mobilization, from June 17 until July 22, 1863, was for service in Pennsylvania during the Gettysburg Campaign, in which 1 man was wounded during two skirmishes. (The unit should not be confused with the Seventy-first New York Volunteers, part of the Excelsior Brigade. See below.)

Several militia regiments were able to recruit a full roster of one thousand men and offer their services as state volunteer units. Long Islanders served in two of these regiments. When mustered in, the units were usually given different regimental numbers; both are given here.

Ninth New York State Militia/Eighty-third New York

This regiment was designated the Eighty-third New York after Fort Sumter. Its 850 men, who included several from Flushing, left Manhattan on May 27, 1861, for Washington. It returned on June 11, 1864, after 379 were killed at the Second Battle of Bull Run, South Mountain, Antietam, Fredericksburg, Chancellorsville, Gettysburg, the Wilderness, Spotsylvania, Cold Harbor and other engagements.

Fourteenth Brooklyn New York State Militia/Eighty-fourth New York

In 1860, the regiment adopted a version of the distinctive French Chasseur uniform that was worn for its entire three years of active duty that began in May 1861. While most of its soldiers came from Kings, it recruited men throughout Long Island, including Alfred Copley of Roslyn and John A. Brown of Riverhead. A letter from a soldier identified only as "SHT" in the *Brooklyn Eagle* on June 6, 1861, described the new recruits' camp life:

> There are…8 men in a tent. Each tent elects a…captain of the mess. Our captain of the mess is lord of all, and we are just as much bound to do what he says as we are to obey our real officers. Two men are detailed to cook, two to bring water, two to wash the dishes and two to clean the tent…The only thing we have to cook with is a sheet iron pot; in it we make our coffee, roast, boil, fry or broil our meat, and boil our potatoes, beans, rice, etc.

Also known as the Brooklyn Chasseurs, the regiment took part in most of the major battles in the East. The first commander, Colonel Alfred Wood of Queens Village, was the highest ranking Union officer captured at First Bull Run, where the Fourteenth sustained 142 casualties. It was there that the unit was given the nickname "Red Legged Devils" by Confederate general Stonewall Jackson because of its uniforms and persistence. The Fourteenth received another 175 casualties at Second Bull Run in 1862. At South Mountain and Antietam, the Confederates inflicted 55 casualties.

After South Mountain, the *Corrector* lamented that "the Brooklyn Fourteenth has been 'gloriously decimated.' One year ago they numbered 1000 men. In the late battles they fought with but eighty of their original members. The rest were raw recruits and numbered some 300 all told. Death gives the soldier

Colonel Alfred Wood of the Fourteenth Brooklyn, 1861. *Courtesy of the Library of Congress.*

an honorable discharge." Among those receiving that discharge was Alanson Pearson of Sag Harbor, shot in the head.

The Fourteenth was one of the few regiments to fight through all three days at Gettysburg. The Red Legged Devils were some of the first infantry to engage the Confederates on the first day, capturing most of Davis's Mississippi Brigade in the railroad cut north of town. Over the next two days, the men resisted heavy attacks on Culp's Hill. They suffered 217 casualties over the course of the battle, 67 percent of the regiment's strength. The Fourteenth ended its service with General Ulysses S. Grant's Overland Campaign in Virginia the following year, taking another 126 casualties at the Wilderness and Spotsylvania. The veterans of the Fourteenth returned to Brooklyn to a hero's welcome on May 25, 1864, having suffered 717 casualties—41 percent of their manpower.[35]

VOLUNTEER INFANTRY

Fifth New York

Organized by New York City merchant Abram Duryée, the Fifth ("Duryée's Zouaves") wore flamboyant Zouave outfits of baggy red trousers, a red fez with yellow tassels, a blue jacket with red trim, a red sash and white leggings patterned on the outfits donned by the French army's Algerian troops. The two-year regiment was mustered in on May 9, 1861, at Fort Schuyler in the Bronx. Its volunteers came from throughout the metropolitan area, including

Astoria, Flushing, Jamaica, Hempstead and various spots in Suffolk. Two of its officers were Hiram and George Duryea of Glen Cove, sons of the owner of the Duryea Corn Starch works there. After Abram Duryée's promotion to brigadier general, Hiram Duryea assumed command of the unit, which is often called Duryea's Zouaves as a result. Hiram served until November 1862; George, promoted to lieutenant colonel, remained with the regiment throughout its two-year term of service.

The regiment left for Virginia on May 23 and soon earned a reputation as a fine combat unit. The Fifth first came under fire leading the assault against entrenched Confederates at one of the first battles of the war at Big Bethel on June 10. The following spring, the regiment joined the Army of the Potomac for the Peninsula Campaign, in which at Gaines' Mill on June 27, the Fifth lost 162 of its 450 men. Their finest hour was at Second Bull Run on August 30, 1862, when the heavily outnumbered Zouaves doggedly held their position until overrun, with 117 of the 490 on the field—23 percent of their number—killed or mortally wounded, the greatest number of fatalities for any infantry regiment in one battle. The survivors served through Antietam, Fredericksburg and Chancellorsville without serious losses before mustering out in New York on May 14, 1863.

One of the Fifth's volunteers was Benjamin T. Davis, a seventeen-year-old Port Jefferson clerk and Miller Place native who quit his job eleven days after Fort Sumter, lied about his age and enlisted on April 23, 1861. Descendants say the son of a ship captain served as a courier for General George Meade. On September 26, 1862, he was promoted

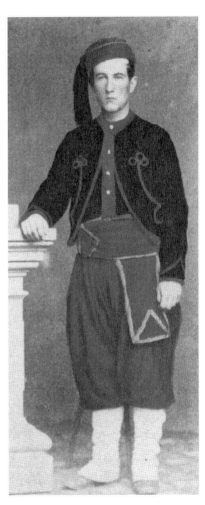

Sergeant Benjamin Davis in his Duryée Zouave uniform, which has been preserved by the Suffolk County Historical Society. *From the collection of the Suffolk County Historical Society.*

to sergeant. After being discharged, Davis operated a stable in New York. According to family legend, Meade told him that if he needed a job after the war, he should come see him; Davis did and became head of the livery service at the Fifth Avenue Hotel in the city. Later he ran a stable in Riverhead, where he died at age seventy-five in 1919.[36]

Twelfth New York

The regiment began as the Twelfth New York State Militia Regiment, recruited in Syracuse and surrounding cities, and was mustered in on May 13, 1861. After ninety days' service defending Washington, the regiment was reorganized as a two-year volunteer unit, recruiting principally in New York City, Patchogue and Buffalo. The Brookhaven volunteers assigned to Company C included John Gilbert Homan, a seventeen-year-old fisherman who enlisted on November 17, 1861.

On April 4, Homan and his colleagues got their first taste of soldiering when they marched eleven miles to Great Bethel, Virginia, discovered that the Confederates had already evacuated the fort there and then retraced their route. The Twelfth then participated in the siege of Yorktown during the Peninsula Campaign. The soldiers worked nights building works under Rebel artillery fire with lookouts who would watch for shells so the diggers could take cover. While there, Homan took note of some of the first aerial reconnaissance in history as officers daily ascended in a balloon to check on Confederate movements. He recalled that one day, when General Fitz-John Porter went aloft, the tether came loose, and the balloon floated away over Yorktown; luckily for Porter, a wind shift brought the balloon back over Union lines. Meanwhile,

> *The Rebels getting the range directed their fire to where the balloon was and we received a lively shelling…One ball went through the drummer's tent and through his drum while he was asleep. It did not hit him or wake him up. While here in front of Yorktown and not on duty, the boys could go to a creek close by for swimming and getting oysters. These oysters were too fresh [water] to taste as good as the "Blue-points" we had been used to, but they were oysters and a good change from our army ration.*

The Twelfth moved up the peninsula later in May to fight in the Seven Days battles. At Hanover Court House, Homan said the body of a dead

Confederate "had been hit by a cannon ball and was doubled up, head and feet together. It was a ghastly site, and lay where we had to march over it." Until that point, Homan wrote, "We had been in the service about six months and had been in three engagements—Great Bethel, Yorktown and Hanover Court House, but did not fire a gun." That changed at Gaines' Mill on June 27:

> *About 3 P.M…the enemy commenced a heavy artillery fire, and a few minutes after their first line was seen coming. As the artillery fire slackened we heard them roaring. The order to commence firing was given and we were in our first heavy battle. It was load and fire and aim low. The rebel line came to about 200 yards from us when they stopped, fired a volley or two, and went back to the woods where they started from. We stopped firing and had a few minutes before another charge was coming…We were pumping lead as fast as we could. My gun was so hot I could hardly use it, but before the rebel line got to us we broke them…A ball stuck fast in the middle of my gun…Gen. Butterfield rode up to our line and said "Fall back, we are nearly surrounded."*

The men retreated, leaving knapsacks behind, and Homan recalled, "The balls seem to say 'get a move on'…I saw five men fall near me during that short run of about one-third of a mile." When the Rebels stopped to rummage through the knapsacks, Union artillery fire drove them back to the woods.

At Malvern Hill four days later, the regiment was ordered to advance through a wheat field a little before 6:00 p.m. It was there that Homan

> *first noticed the peculiar zip which a minie ball makes, and the minies were coming thick and fast. It was not a pleasant sound…Our Company lost several men going through the wheat field. Sgt. Corcoran, who was wounded at Gaines Mill, got another in his shoulder, which knocked him out. One man was hit in his mouth knocking out several teeth, and the bullet passing out through the side of his neck. One man had a steel vest on. He was hit in his neck and killed. One man was hit on top of his head, making a furrow through his hair and just breaking the skin…Other charges were made, but we broke them, and held a position on the hill until dark…One bullet grazed my cap, taking it off my head.*

The Union forces fell back to Harrison's Landing on the James River, where the Twelfth was re-provisioned after a week without tents or blankets.

With his nautical background, Homan "was detailed quite often for duty on the river, rowing officers to different boats. On one occasion we went to the little *Monitor*, which was anchored there, and I had a good look at her—the first iron-clad—the boat that a short time before had whipped the iron-clad *Merrimac*, and revolutionized the navies of the world."

The Twelfth begin marching back down the peninsula on August 14, one day traveling thirty-five miles while bearing a heavy load:

> *Our tent and blanket were carried in a roll over our shoulder. Our haversack held our five days rations of hard-tack, salt pork, coffee and sugar. Our canteen held three pints of water and our cartridge box held 40 cartridges, with 20 more to be carried in our pockets. Then we had our musket and was prepared for any duty.*

The regiment moved back to Manassas for the Second Battle of Bull Run, where it was ordered to charge across an open field to reach Confederates behind an embankment, and Homan noted, "Our men were falling fast. The peculiar thud made by a ball hitting a body was heard plainly and often." As the attack faltered and the men ran back to the woods under fire, a bullet struck the handle of a hatchet that he carried on his belt, cutting it in two. Another ball severed the blanket over his shoulder. "I was going as fast as it was possible…when I fell in a heap. I tried to get up but could not…Then I knew I was hit in my leg. I did not feel any pain. My leg seemed to be numb."

Counterattacking Confederates overtook him, but instead of making the eighteen-year-old a prisoner, they moved him next to a tree, laid him down on blankets and covered him with a rubber blanket that kept him dry during the rain that fell that night. "One shell burst near where I lay and one piece of it struck a rebel on his shoulder, tearing off his arm…Another shot hit the tree I was lying behind, which stunned me for a few minutes. The next morning the Rebels counted nearly 20 Minie balls which had struck the large tree that I lay behind." Homan wrote that a Confederate officer reined up by him and asked what brigade he belonged to before riding off. "I asked a straggler who he was and was very much surprised to hear that it was Stonewall Jackson."

Besides Homan, the regiment had 142 men killed, wounded or missing at Second Bull Run. After the battle, he was picked up by Confederate stretcher-bearers and taken to a field hospital where it was found that a bullet still in his lower right leg had shattered bones. A surgeon told him, "That leg must come off," and was preparing to amputate until a

wounded Union infantry officer who knew Homan intervened. The Confederates paroled Homan because they did not have enough troops to guard prisoners. He had nothing to eat for the next four days, and the following day he was loaded onto the front seat of a Union ambulance and jostled for twenty miles to Washington. He was laid on a bed in Emory Hospital—"The first bed I had laid on since leaving home the winter before." He would be in the bed for a month before he got crutches and would remain in the hospital three months before being transferred to Camden General Hospital in Baltimore—a jolting train trip that put him back in bed for three weeks. As he recuperated, he began going to a nearby farmers' market where he was given cheese, eggs and fruit to supplement the boiled salt cod, potatoes and bread of the hospital. After one year in the service, "on Thanksgiving Day we got a grand lay-out, Roast turkey and fixings, with pudding and pie and all we could eat," compliments of the Ladies Union Relief Association. Gangrene was diagnosed twice in his leg, but doctors avoided amputation through the use of three kinds of poultices, containing flaxseed; bran and yeast; and bread and milk. In mid-January 1863, doctors told Homan that he needed to have bone fragments removed from his leg for it to heal properly, so he was given chloroform and went under the knife. When the incision healed, he was able to walk with one or two canes and so was discharged. He returned to Patchogue after fifteen months in the army. "The toils and duties of my soldier's life was over and I was a civilian again—and a cripple for life." While Homan was recuperating, the Twelfth fought at Fredericksburg. The original two-year volunteers were mustered out at Elmira on May 17, 1863, and the three-year men were transferred into the Fifth New York Veteran Infantry. The casualty total for the Twelfth was 69 deaths from wounds and 68 from other causes.

Fortieth New York

The "Mozart Regiment" was sponsored by the Mozart Hall faction of the New York City Democratic Party, the rivals of Tammany Hall. It was organized at Yonkers and mustered in on June 21, 1861. Its ranks, which included Hempstead and Jamaica volunteers in Company I and, later, additional men from Oyster Bay, were filled out by five companies from Massachusetts and Pennsylvania. The chaplain was William H. Gilder Sr. of Flushing, whose son William Jr. was an officer in the regiment.

The three-year unit left for Washington on July 4 and was soon shifted to Alexandria, Virginia. After a year of training, the Mozart men participated in the Peninsula Campaign, taking part in the siege at Yorktown and Battle of Williamsburg under their beloved general, Philip Kearny. During the Seven Days, the hard-fighting Fortieth suffered 100 casualties. Despite heavy losses at Second Bull Run in August, the regiment still fought well at Chantilly, where the regiment was credited with saving the day. After further casualties at Fredericksburg and Chancellorsville, the regiment was reinforced with new recruits, including some from Oyster Bay.

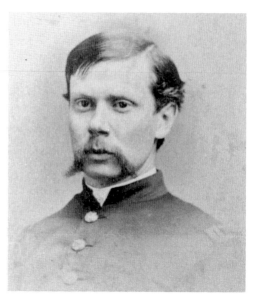

Lieutenant William Gilder Jr., Fortieth New York Volunteers. *Courtesy of the U.S. Army Heritage and Education Center.*

They soon got to prove their worth at Gettysburg, where the Fortieth endured 150 casualties fighting in the Valley of Death between Devil's Den and Little Round Top. Additional recruits made up for these losses before the army began its 1864 Overland Campaign. After further service at the Wilderness, Spotsylvania, the North Anna River and Cold Harbor, the remaining original members of the regiment were mustered out in July 1864. Those with time remaining in their enlistments continued serving with the Fortieth, as did survivors of the Seventy-fourth New York (see below). The veteran unit took part in the siege of Petersburg and pursued Robert E. Lee's forces to Appomattox. The regiment was mustered out at Washington on June 27, 1865. Its losses over four years—238 killed or died of wounds and 172 from disease or other causes—were higher than every New York regiment except the Sixty-ninth "Fighting Irish."

Forty-eighth New York

The regiment was known officially as the "Continental Guards" and unofficially as "Perry's Saints" after its organizer, Colonel James Perry, a West

Point graduate and former military officer who had left the army to become pastor of the Pacific Street Methodist Church in Brooklyn. Perry wanted the three-year regiment to have a reputation for high moral character. The recruits came from Brooklyn primarily but also Manhattan, New Jersey, upstate and even Massachusetts and Connecticut. The regiment sponsored a recruiting meeting in Northport in August 1861 and enlisted men from that village, Centerport and Huntington.

The unit was mustered into federal service in Brooklyn beginning August 16 and headed for Washington on September 16. A volunteer in the Forty-eighth identified only as "Harman" and presumably a sergeant wrote in a letter published in the *Brooklyn Eagle* on October 7, 1861, about his life as a soldier:

I will give you a detail of our day's work. Reveile [sic] at sunrise, when every officer and private must be present at roll call; squad drill until 7-1/2 o'clock; non-commissioned officers drill from 10 to 11; company drill from 11 to 12; then dinner. After dinner men sent to bathe 2 o'clock, company drill 4 o'clock, regimental drill 5 o'clock, dress parade, then supper. After supper company books to be written up; 9:00, tattoo; signal for roll call, 9:00; taps, when all lights must be put out; then besides that you have to clean yourself and equipments, see that details are sent down to the river to scrub and shave some dirty loafer who is "crumby," and so you see that we have not much time to ourselves.

The regiment participated the next year in the capture of the fortifications at Port Royal in North Carolina and the successful siege of Fort Pulaski on the Georgia coast. The Forty-eighth then garrisoned the fort, where it earned another distinction: a photograph of the soldiers taken there shows what historian Ric Burns has identified as one of the earliest pictures of a baseball game.

Most of the regiment shifted to South Carolina for operations to capture Charleston. The Forty-eighth participated in the costly attack on Fort Wagner on July 18, 1863, along with the first African American regiment raised in the North, the Fifty-fourth Massachusetts, whose story was chronicled in the movie *Glory*. The Forty-eighth held on to a section of the fort longer than the Fifty-fourth Massachusetts and had more casualties: 242 killed, wounded and missing. A member of Company A described the brutality of the assault in a letter to the *Brooklyn Eagle*:

The Forty-eighth New York at Fort Pulaski, Savannah, Georgia. The men in the background are playing baseball, a popular Civil War pastime. *Courtesy of the U.S. Army Heritage and Education Center.*

On the parapet nothing but hand-to-hand fighting was carried on, every inch being doggedly contested; in this manner we drove them inch by inch until we got all but one small corner of the battery…Just as our boys were on the point of carrying it, the rebels received reinforcements from Sumter and very quickly drove us from all that we had taken possession of. The rebels took no prisoners but well men, those wounded were thrown over the parapet into the moat which encircles the fort, and were drowned…Our colors were riddled like a sieve…I never before witnessed such a wholesale human butchery, nor never wish to again.

Moving to the Florida Panhandle, the regiment took part in the disastrous battle at Olustee, with 44 casualties. In April 1864, the Forty-eighth was transferred to Bermuda Hundred near Richmond, Virginia. It fought in the Battle of Cold Harbor and was part of the first assault on Petersburg before the original volunteers mustered out in New York

City on September 24, 1864. Since 350 men had reenlisted the previous December, the regiment continued to serve until the end of the war, doing its last fighting at Fort Fisher and Wilmington, North Carolina, in January and February 1865. It then transferred to Raleigh, North Carolina, where it was mustered out on September 1, 1865. Over its four years of service, the Forty-eighth had 243 soldiers killed or mortally wounded and another 123 lost to disease or other causes.[37]

Fifty-seventh New York

The Fifty-seventh, known locally as Zook's Regiment after commander Colonel Samuel Zook, was organized in the fall of 1861. Among its recruits were 16 young men from Patchogue and at least 22 from other Suffolk villages, including Lieutenant Henry Brewster of Islip. The regiment first saw combat on the peninsula in 1862. It was heavily engaged at Antietam in September, losing 98 killed and wounded in that bloodiest day of the war, among them J. Edwin Ruland of Moriches. Three months later, there were another 87 casualties at Fredericksburg. Following hard combat at Chancellorsville and in the Wheatfield at Gettysburg, the Fifty-seventh took part in Grant's campaign in Virginia in 1864. It was mustered out in the fall of 1864, having lost 103 men in action and 91 from disease and other causes.

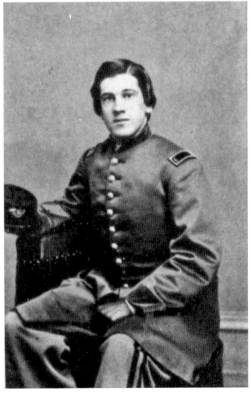

Lieutenant Henry Brewster in the uniform of the Fifty-seventh New York Volunteers. *Courtesy of the U.S. Army Heritage and Education Center.*

45

Sixty-seventh New York

The unit commonly known as the "First Long Island Regiment" was also known as "Beecher's Pets," as some companies were raised by famous Brooklyn preacher Henry Ward Beecher. The regiment recruited primarily in Brooklyn but included men from across Long Island, among them Franklin Stillwell of Hempstead. Mustered in for three years' service in June 1861, the regiment left Brooklyn for Washington on August 21 and the following March joined General George McClellan's Peninsula Campaign, earning a mention in "The Seven Days' Fight," a period song: "Then came the First Long Island—we did our work quite well, As many a wounded rebel from experience can tell." After incurring slight losses at Fredericksburg, the next summer the Sixty-seventh was engaged at Salem Church, Virginia, and Gettysburg; the spot where it fought on Culp's Hill is proudly marked with a monument to the

Left: Private Franklin Stillwell of the First Long Island Regiment. *Courtesy of the Nassau County Photo Archives.*

Below: The First Long Island in training at Camp Palmer outside Washington, D.C., 1861. *From the collection of Harrison Hunt.*

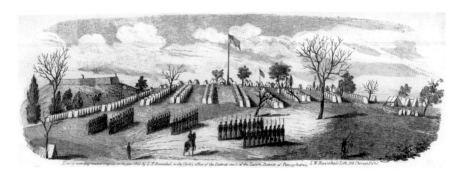

"First Long Island" (see photo, page 130). The following year, the unit had 93 casualties out of 270 men engaged at the Wilderness and another 48 losses at Spotsylvania Court House. The survivors continued fighting in the battles leading up to the siege of Petersburg. On June 20, the original members who had not reenlisted left for Brooklyn and were mustered out. The reenlisted veterans and recruits were consolidated into the Sixty-fifth New York and helped turn back Jubal Early's raid on Washington, pursuing him through the Shenandoah Valley before returning to Petersburg for the end of the siege. The regiment lost 112 by death from wounds and 77 from other causes during the war.[38]

Fifth Excelsior/Seventy-fourth New York

This regiment was part of the Excelsior Brigade organized by General Daniel Sickles under direct authority from the president in 1861. The five regiments were later accepted as New York volunteer forces and given state numbers, but the men always referred to their unit as the Fifth Excelsior. Company C was recruited in 1861 in Flushing and Jamaica and later the three towns that would eventually be part of Nassau County. "Captain Quarterman's Company," as it was initially known, was one of only two infantry companies raised within Queens (Benjamin Willis's company in the 119th was the other) and the only one created from the prewar Queens County militia, the 15th Regiment. Under the leadership of George H. Quarterman, captain of the Flushing company of the 15th, ninety men from Flushing and Jamaica were quickly signed up and left for training at Camp Scott on Staten Island on June 7.

Quarterman's men made a good impression as they were designated Company C, a position of honor at the center of the line that included the color guard. The unit departed for the "seat of war" on July 24, three days after the Union defeat at the First Battle of Bull Run, and arrived at Camp Marsh in Washington two days later.

One of the volunteers was eighteen-year-old English immigrant Michael Shaw of Jamaica, a typesetter with the *Long Island Democrat*, which proudly declared him its "Fighting Editor"; the newspaper printed his correspondence for two years. Shaw noted that the food was often terrible even on special occasions: his Thanksgiving 1861 meal consisted of "four crackers (hard as the worst sinner's heart) and a…chunk of salt-horse" or heavily salted beef.

The Excelsior Brigade participated in its first real battle in the spring of 1862 during the Peninsula Campaign. Shaw reported on the Battle of Williamsburg on May 5 that

The way the bullets whizzed around us was a caution, and pretty nearly all the tallest men were killed, but I came out without a scratch…If you want to see something horrible I would advise you to come out here on the first day after a battle [and] walk over the field and if you don't reel with sickness at the sight of the cruel carnage, you are farther gone in hardihood than I should like to be. These noble wrecks lying all round you once animate with life and hope…The groans of the wounded still ring in my ears and ghastly forms crowd before my eyes—limbs without bodies, bodies without limbs—gore of men and horses mingling in one common pool—friend and foe locked in a death grip and dabbled with each others blood.

Quarterman's Company lost seven killed, six missing and nine wounded, among them Quarterman. "I…received a wound in each of my shoulders, in each leg, and in my hand," the captain wrote home on May 7. "Tell father *I fell with my face to the enemy.*" Quarterman's men reported that he fought as long as he could, grabbing a rifle when he could no longer stand and firing until he passed out. He lay there overnight through a drenching rain while Confederate soldiers appropriated his sword and pistol. By the time McClellan abandoned the peninsula three months later, Company C had only thirty-two men in the field.

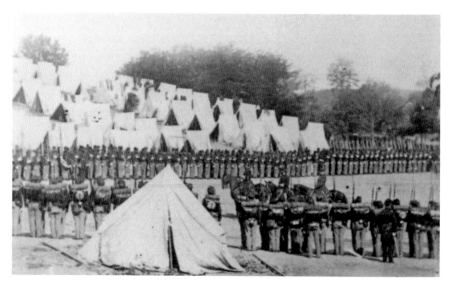

The Excelsior Brigade in camp, 1862. *Courtesy of the U.S. Army Heritage and Education Center.*

The Peninsula Campaign also had a significant impact on the regiment's second-in-command. Among the militia members who signed up for state regiments to fight for the Union was the Fifteenth Militia's Major Charles H. Burtis, who was commissioned as a lieutenant colonel in the Fifth Excelsior. Burtis, born in 1830 in Oyster Bay, was a descendant of Pietro Caesar Albertus, the first Italian immigrant to America in 1635, and the Town of Oyster Bay tax assessor. On the peninsula, Burtis "fought not only wisely, but too well, as the fatigue he underwent resulted in illness, which compelled him to resign." He came back to Oyster Bay to recuperate, and the following year, he returned to duty as the colonel of the Fifteenth Militia.

The Fifth Excelsior saw action again in 1862 at the Second Battle of Bull Run and Chantilly in Virginia, which, the *Flushing Journal* reported, "put the finish to Captain Quarterman's Company; there was not an effective man left." Of the ninety-five men assigned to the company in 1861, sixteen never served and another sixteen were transferred to other units or "skedaddled" as deserters; fifteen were killed on the peninsula or at Second Bull Run; and at least forty-one were killed by disease, discharged, transferred, on detached duty, missing or in the hospital by September 1862, for a loss of eighty-eight. In response, the unit signed up thirty new men from Flushing and thirty-six from other towns. Like the initial recruits, they were a diverse lot. Isaac Southard of Oyster Bay and Edward Gunn of Manhasset were farm laborers; several were boatmen or baymen like John Tyson of Port Washington and Charles "Buff" Johnson of Baldwin; Charles Nebe of Hempstead was a butcher; and James Perry of Port Washington was a blacksmith.

The following year, Company C's veterans and new recruits saw some of the unit's hardest fighting at Chancellorsville and Gettysburg. Posted in an exposed position adjacent to the Peach Orchard on the second day of Gettysburg, the company lost three killed and fourteen wounded. There were another eleven casualties while pursuing the retreating Confederates at Wapping Station, Virginia. After the Fifth Excelsior's final engagements at Spotsylvania and the Wilderness in May and June 1864, the regiment was disbanded. Those men with service time remaining, including nine original members of Company C who reenlisted, were transferred to the Fortieth New York Veteran Volunteers. With the Fortieth, they took part in the siege of Petersburg and pursuit of Lee's army to its surrender at Appomattox Court House on April 9, 1865. Private Robert Wright of Flushing was killed just three days earlier, at the Battle of Saylor's Creek, the final member of Company C to die in service to his country. The remaining men were mustered out on June 27, 1865.[39]

Eighty-first New York

Quite a few young men from Sag Harbor and the rest of the South Fork signed up for Company H of the Eighty-first even though the rest of the regiment was raised in upstate Oswego and Oneida Counties because the regiment was commanded by Colonel Edwin Rose of Bridgehampton, whom they knew and trusted. The Eighty-first, also known as the Oswego Regiment, was organized in Albany on February 18, 1862, and headed off to the war on March 5. From Washington, the unit moved to Virginia to participate in the Peninsula Campaign. It did not see combat at the Battles of Williamsburg and Savage Station, but James Wallace Burke of Sag Harbor wrote about visiting the field of the latter engagement in the *Corrector* on May 31:

> *The scene was truly pitiable—men wounded in all parts of the body lay in crowds in all the barns, outbuildings, sheds and temporary shelters that could be found...Their cries, groans and shrieks moved the stoutest hearts. All the afternoon the surgeons had been busy and all night they continued by the dim lights of lanterns and flaring candles to amputate limbs. Great numbers of surgeons were thus engaged but the greater number of the wounded made it impossible to attend to them as fast as the cases required. Many died and were thus saved from further mutilation.*

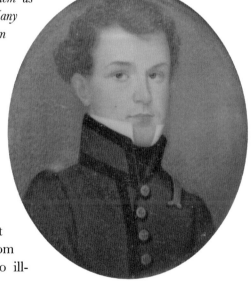

The Eighty-first had its baptism of fire at Fair Oaks, where it suffered 137 casualties on May 31 and June 1. That November, the regiment was transferred to the North Carolina coast, returning to Virginia in late 1863. It fought in 1864 at Drewry's Bluff downriver from Richmond and in Grant's two ill-

Colonel Edwin Rose of the Eighty-first New York Volunteers early in his military career.
Courtesy of Geoffrey Fleming.

advised frontal assaults against entrenched Confederates at Cold Harbor, where the regiment incurred its heaviest casualties of the war: 212 killed or wounded and 3 missing—a 50 percent casualty rate. Despite these losses, enough soldiers reenlisted for the Eighty-first to continue as a veteran regiment, and it continued fighting in the battles before Petersburg and Richmond until the cities fell on April 3, 1865. The regiment was mustered out at Fortress Monroe on August 31, 1865. Over its service, the Eighty-first saw 107 killed from wounds and 99 deaths from other causes.

Ninetieth New York

The companies of the regiment were mustered in for three years between September 1861 and April 1863. The men came from upstate, New York City, Brooklyn, Glen Cove, Jamaica and Amityville. The regiment left New York on January 5, 1862, to serve at Key West, Florida, where the men had a quiet life, even publishing a newspaper, the *New Era*. Early in 1863, the Ninetieth was transferred to New Orleans and then up the Mississippi to Port Hudson, where it endured 50 casualties in the siege. In June and July, it was engaged at Bayou La Fourche and in March 1864 participated in the Red River Campaign. Following that, the regiment was ordered to the Shenandoah Valley and fought at Opequan, Fisher's Hill and Cedar Creek. The original members who did not reenlist were mustered out in December 1864, and the remainder served in Washington until the spring of 1865 and then in Georgia, where they were mustered out on February 9, 1866. It lost 60 by death from wounds and 190 from other causes.

102nd New York

A number of men from Cold Spring Harbor followed Captain Walter Restored Hewlett into Company C of the 102nd. Other recruits for the three-year regiment known as the Van Buren Light Infantry came from Manhattan, Brooklyn, upstate and New Jersey. The companies left for Washington on March 10 and April 7, 1862.

The 102nd fought its first major engagement at Cedar Mountain, Virginia, on August 9, 1862, suffering 115 killed, wounded and missing. The scrappy regiment endured another 37 losses at Antietam in September and 90 at Chancellorsville the following May. At Gettysburg, it had 29 casualties

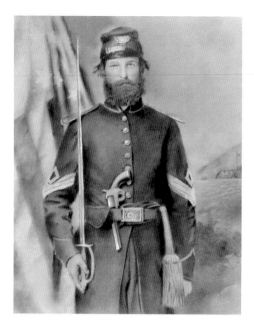

Sergeant Jacob C. Walters in the full dress uniform of the 102nd New York Volunteers. *Courtesy of the Huntington Historical Society.*

defending Culp's Hill in the same area as the First Long Island. Following Gettysburg, the 102nd was transferred to Tennessee, where it participated in the battles around Chattanooga, including Lookout Mountain, where the regiment was part of the advance wave, and Missionary Ridge. It then took part in General William T. Sherman's Atlanta Campaign, fighting at Resaca, Kennesaw Mountain and Peachtree Creek. It was with Sherman during his March to the Sea and the siege of Savannah and closed out its service in the Carolinas. The 102nd was mustered out on July 21, 1865, at Alexandria, Virginia. During its service, it had fought in more than forty battles in seven states and had 74 killed and mortally wounded in battle and 82 die of disease, accidents and other causes.

119th New York

One of only two infantry companies raised within Queens County, Company H of the 119th was organized in Hempstead and North Hempstead by lawyer Benjamin Willis of Roslyn. Willis held recruiting rallies in Hempstead, Roslyn, Baldwin, Freeport and the Rockaways in August 1862, challenging men to "prove yourselves worthy of the nineteenth century!" One hundred patriotic young men responded, including nineteen-year-old painter's assistant Charles Fletcher Raynor of Baldwin; John Cornelius, a hostler or groom from Hempstead; Roslyn harness maker Alfred Noon; thirty-three-year-old ship joiner George Rudyard of North Hempstead; John Albro, a bayman from Far Rockaway; and German immigrant Henry Camps, a Hempstead farm laborer. When the company was accepted for service, Willis

was commissioned captain. The regiment left for Washington on September 6 to defend the capital; while there, Willis Company, as it was known, received a distinctive American flag made by the ladies of Hempstead.

Army life there definitely did not agree with John Carman, twenty-one, a vegetable farmer from Merrick. He wrote on October 3, 1862, when Willis Company was encamped at Fairfax Courthouse, that "i am tiered of a soldiers life and i want to get to Long Island."

The first major battle for the 119th was in May 1863 in Chancellorsville, where the regiment was one of those surprised by Stonewall Jackson's flank march and lost twenty-one killed, including the commanding officer, Colonel Elias Peissner, who was trying to rally his men. There were also sixty-seven wounded and thirty-two missing.

Henry Camps described the battle in a letter in the *Queens County Sentinel* on May 14:

> *I came out of the late great battle at Chancellorsville, all safe and sound, not even receiving a wound or scratch, although 7 of my best comrades were killed by my side. One in particular, a young man…named Dunn…was sitting beside me shooting away at the rebels when a rebel bullet*

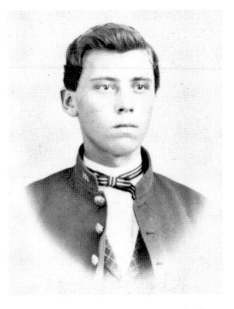

Private Samuel DeWitt of Hempstead, who served with Willis Company from 1862 until 1865. *Courtesy of the Company H, 119th New York Volunteers Historical Association.*

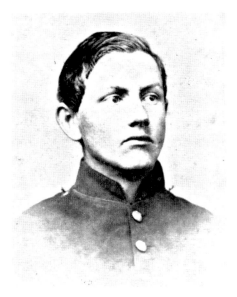

Private Charles Fletcher Raynor of Freeport in his Willis Company uniform. *Courtesy of the Company H, 119th New York Volunteers Historical Association.*

struck him in the head, scattering the poor fellow's brains all over my face and shoulders. There was 12 of us belonging to the color guard and out of these 9 were killed, but I made out to bring the United States Flag off the battlefield when it was nearly in the hands of the rebels. It was lying on the ground under one of our dead, and the rebels were within four rods [sixty-six feet] of us and our regiment running like mad for the woods, leaving me all alone, but I made up my mind that I could not stand the disgrace of leaving that beautiful banner on the battle-field, so I made a rush for the flag rolling the body from it, picked it up and put it on my shoulder, running like every thing for the woods with it, and… the bullets were flying around my head and feet like a parcel of bumble bees, but none of them struck me. After getting through the woods I could not find my regiment, but I saw some troops forming in line of battle and I got in with the 40th New York Regiment. Then the rebels were coming on us in great force, and we let them come to within about 200 yards when we opened five batteries on them all at once, the guns being loaded with grape and canister, and you could see them fall like grass behind a mowing machine.

The 119th was heavily engaged on the first two days at Gettysburg (see page 103), suffering 140 casualties and earning Benjamin Willis promotion to major. In September, the regiment transferred to Tennessee and fought at Missionary Ridge before participating in the campaign to relieve Knoxville. In the spring of 1864, the men of Company H were assigned to the Atlanta Campaign. They fought at Resaca, Kennesaw Mountain, Pine Hill and Peachtree Creek, losing several men, including George Rudyard, Dandridge Mott of Freeport and Erastus Webster of Roslyn, before the capture of Atlanta. In November, the regiment marched with Sherman to the sea and was one of the first regiments to enter Savannah. Early in 1865, it moved with Sherman into the Carolinas, participating in several battles, including Bentonville. The veterans of Willis Company were mustered out at Bladensburg, Maryland, on June 7. On their return home, they presented Major Willis with the flag the women of Hempstead had made for them three years earlier. During the war, 77 men from the regiment were killed or mortally wounded in battle and 94 died from disease and other causes. The unit's history is kept alive by a group of reenactors based at Old Bethpage Village Restoration.[40]

127th New York

The regiment with the most Suffolk men by far was the 127th New York. It was recruited in the summer of 1862 in New York and Long Island. Company D included volunteers from Huntington, Southampton and Greenport; Company E and part of Company I were raised in Huntington Town, which included current-day Babylon; Company G had men from Sag Harbor, Riverhead and Greenport; Company H drew its men from Mattituck to Orient on the North Fork, while Company K and part of Company G were composed of South Fork and Greenport boys. The three-year regiment dubbed itself the "Monitors," not after the famous ironclad warship whose image it used as a unit logo, but

Orient men in Company H, 127th New York, taken at Alexandria, Virginia, February 28, 1863. John Henry Young is in the back row, second from left. *From the collection of the Oysterponds Historical Society.*

because its recruits pledged to mutually monitor one another's behavior. Soldiers in other regiments nicknamed the men of the 127th "clamdiggers" because of the baymen from Company K, but the moniker was eventually applied to the entire unit. Among the soldiers in the 127th was John Riddell, editor of the *Suffolk Times* on the North Fork, who ran a recruitment ad for the 127th in his August 21, 1862 issue and then enlisted, becoming a sergeant.

John Henry Young of Orient wrote about signing up on August 24, 1862, in his diary, now in the possession of the Oysterponds Historical Society: "Pleasant and cool morning went bathing went to church had a splendid sermon. This day concluded to volunteer for the war." He took the train to New York the following day and the day after that wrote, "Bought a revolver…am now a soldier."

The regiment was mustered in on Staten Island on September 8, 1862, and two days later was sent to defend Washington. The 127th served most of its time in South Carolina and Florida.

Young's diary for 1863 offers glimpses of camp life and the soldier's gallows humor and makes clear that he hated his time in uniform:

> *May 10…had bean soup for dinner having had nothing but pork and hardtack for a week. At 3 o'clock fell in again for digging was relieved at 7 o'clock. This is what I call "keeping the Sabbath day holy."*

The Monitors at Camp Morgan, Virginia, in the fall of 1862. *Courtesy of the U.S. Army Heritage and Education Center.*

Tuesday June 16th…slept splendid last night cartridge boxes make soft pillows.

Sat August 1st…the whole division marched to an open field to witness the execution of a deserter. After he was shot all passed in review by the body where it lay just as it fell behind the coffin with his bared bosom pierced by the deadly bullet…

Wednesday August 27th…Have belonged to Uncle Sam 1 year don't wish to be under him another. Hard master.

On April 27, 1863, Young wrote his cousin from camp near Suffolk, Virginia:

We are out on fatigue about every day. Throwing up entrenchments. Sundays not excepted. There are no Sundays in the army…It is our busiest day. The first thing after we get up is to go to scouring up brass cleaning gun &c for a thorough inspection. Oh we are humbugged to death. We came here out of pure motives but we have learned so much now that no money would induce us to come again. We didn't come to polish brass or black shoes. We have an everlasting grudge against our officers and would sooner shoot them than the rebels any day…They look down upon us and treat us worse than dogs… We have to get up every morning at 4 o'clock form line of battle and stand till daylight then stack arms in Co. street & keep equipments on till seven. One of the Humbugs of the army.

In letter from Coles Island, South Carolina, on March 9, 1864, Young wrote:

Would you like to know what we eat drink and wear? Well, in the first place bread is the most indispensable article of this we have a loaf a day which weighs about 20 ounces. I don't see but that it is just as good as you have at home though you might not think so. Next we have four kinds of meat… Fresh beef two or three a week, pork, bacon, and salt hoss. We get a piece of meat for breakfast and dinner. Coffee for breakfast and tea for supper for dinner when in camp either bean soup beef soup or potato & onion stew for supper Hominy rice or stewed apples. Our clothing is quite simple pants, blouse cap shoes and stocking shirt &c. are allowed $42 a year for clothing. I lived within my income last year but a great many overrun 20 or 30 Dollars which is deducted from the pay a good pair of shoes lasts me 6 months and the first year I only wore out two pairs of pants.

Young wrote several days later that oysters and clams were abundant in the adjacent creeks and rivers. "By the way this reg't is called by those from other parts of the state 'Clamdiggers' because it is mostly from Long Island and we glory in the name."

Rather than being depressed by the bad army fare, Henry W. Prince of Southold said it made him appreciate more the life he had left at home:

As for the cooking, I think if I live to return home I can get a meal pretty quick & would not find fault if there was nothing in the house but a few crusts of bread & some pork, for I would fry the pork and steam the bread & then feel thankful that I had so good a meal. People don't know when they are well off. I now enjoy my ration of pork, hard bread and coffee better than I have many a meal at home when all was before me that heart could wish.

Prince demonstrated that the soldiers did what they could to improve their diet:

Corpl. Latham and I went a round clamming. Got 1-½ bushel of fine ones. At noon we had some fried in batter. (I managed to get a little flour.) I never eat better ones. Last night we had a roast and today a clam stew made of hard tack & pepper & celery.

The 127th suffered its first major losses on November 30, 1864, at the Battle of Honey Hill in South Carolina, losing seven killed, forty-nine wounded and fifteen missing. After the Confederates evacuated Charleston, Sherman designated the 127th to garrison the city because of its reputation for discipline, and the unit was mustered out there on June 30, 1865. The regiment saw thirty-five killed in action, and ninety-five died of disease and other causes.

One of the 127th soldiers who made a name for himself was George Ryerson of Oyster Bay, who became the boxing champion of the Army of the Potomac. Ryerson, a bayman who also worked on his father's farm, had developed a reputation as the best bare-knuckle boxer on the North Shore. In August 1862, Ryerson enlisted as a private in Company E along with six other young men from the hamlet. Shortly after Gettysburg, in July 1863, Ryerson took on all challengers in the boxing ring. In April 1865, when the 127th was in Charleston and Ryerson had defeated the best boxers of the white units in the region, the champion of the U.S. Colored Troops regiments in the area

Captain Hewlett Long, Company K, 127th New York. *Courtesy of the Huntington Historical Society.*

stated he could defeat Ryerson. A fight was arranged with a purse of $100 placed by the officers of the 127th. The match was held at a dock on Charleston Harbor at midnight. Ryerson, then a corporal, stripped to the waist with an American flag wrapped around his uniform pants, according to the recollection of Captain Alonzo W. Fisk of the provost marshal's office. Ryerson wore his army boots, while his opponent, whose name Fisk did not record, was barefoot. Thousands of white soldiers crowded in on one side of the ring while three regiments of black troops were positioned on the other side, all cheering wildly. The fight had gone on for almost an hour with no advantage to either contestant when Ryerson's boots broke the stalemate. He stomped on his opponent's bare feet, and when the black soldier jumped back, Ryerson struck him so hard with his right fist that the challenger was propelled over the ropes into the harbor. After he was mustered out, Ryerson returned to Oyster Bay and resumed working as a farmer.[41]

139th New York

The regiment organized in Brooklyn was mustered in on September 9, 1862. Most of the enlistees were from Brooklyn, but Company A included residents of Hempstead, Brookhaven and Jamaica; Company H a number of recruits from Smithtown; and Company I volunteers from Hempstead, Islip and Jamaica.

It's possible to comprehend vividly what life in the 139th was like, thanks to a series of letters written by Albert and Edward Bayles, brothers who grew

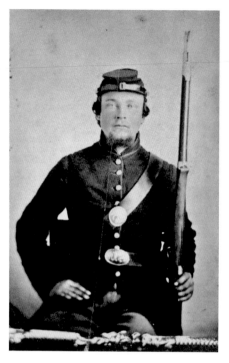

up on their father's Middle Island farm. While Edward, twenty-one, was a farm laborer, Albert, twenty-three, was a teacher who wrote in a perceptive and witty style, as much philosopher as soldier. They enlisted in August 1862 and spent their first month at Fort Greene in Brooklyn while recruiting continued.

The brothers' first letter was written by Albert on August 23, 1862, from Brooklyn, in which he said that, as the soldiers pitched tents, "it seems to me I have never heard so much profanity in all my life before." The 139th on September 11 left for Washington, where Edward wrote, "We went around the city to the Capitol, the house where 'Uncle Abe' lives and at the other public edifices. They rather look ahead of anything around Middle Island."

Several days later, they were transported to Fortress Monroe on the Virginia peninsula between the James and York Rivers, where they camped outside the fort at what was named Camp Hamilton. The brothers slept in tents, drilled and performed guard duty. In late March, the 139th began spending part of its time occupying fortifications outside Confederate-

Top: Private Edward Bayles, 139th New York Volunteers. *Courtesy of the Longwood Public Library, Middle Island.*

Left: Sergeant Albert Bayles, 139th New York Volunteers. *Courtesy of the Longwood Public Library, Middle Island.*

occupied Williamsburg, manning a small redoubt with two twelve-pounders. Finally, in November, the regiment was able to move into more permanent barracks after fifteen months in tents. On December 15, Edward wrote to their grandmother that "we are blessed with good health…Albert seems to like the business first rate, nearly as well as I do, I think, and I think on the whole that it agrees with us very well. He says that I am getting fat and look much more healthy than I did before I enlisted and I think the same by him." While they may have had a lot to eat, the quality of the food was a different matter, Edward wrote:

> *The food we get is not the most wholesome, being fresh and often sour bread, salt meat of the hardest kind and not cooked sufficiently generally, with no vegetables except now and then some white beans that never are cooked soft. I will say we had a few potatoes the other day, being the first we have seen for several weeks.*

Responding to a query from his grandmother about whether they had proper clothing for the cold weather, he wrote, "We are very well provided with clothes. We have woolen shirts and drawers enough together with two undercoats and thick overcoat and two pairs of trousers." He added that on guard the day before he had worn three coats and "kept quite comfortable."

Albert wrote on Christmas Eve that he was just back from company drill "on the sea shore, had an opportunity of seeing some shelling practice from several frigates with mortars. I never before saw water fly like it. A collection of whales could not approach to it…All the while it kept up a strangely musical sound as it flew." Albert wrote on December 31, "You ought to have seen our men last Christmas night. They were a merry set of fellows I assure you. Whiskey had done its work well. The guard house was full and some had to be stowed in the hospital." He asked for a box of potatoes from home because "I am going fully tired of sour bread and salt horse." To his pleasure, the potatoes came by January 7. Like many other volunteers, Albert did what he could to make their camps look better and lighten up the atmosphere:

> *We have now a hen or two, 3 dogs, 3 cats, to say nothing about the rats, which makes things appear like home…You cannot think how much good it does us to hear a dog bark or a hen cackle. The captain has two rose bushes growing before the door of his quarters with roses which enlivens the scene much.*

The regiment fought several minor engagements in Virginia in 1863 with small losses. In May 1864, the 139th participated in the campaign against Richmond and Petersburg, where it was engaged at Drewry's Bluff, Bermuda Hundred and the Battle of Cold Harbor, where the unit sustained 33 killed, 118 wounded and 2 missing. In June, it participated in an assault on the fortifications at Petersburg, and two months later, the regiment was part of the successful assault on Fort Harrison outside Richmond, suffering 41 killed and wounded in the tough fight. On April 3, 1865, the 139th was the third regiment to enter Richmond after Confederates abandoned the city, and it was mustered out there on June 19. During the war, the regiment lost 75 killed or mortally wounded in battle; 80 died of disease or other causes.[42]

145th New York

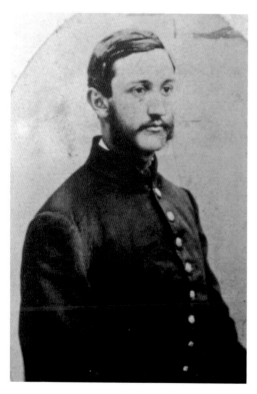

Lieutenant John Gelston Floyd, 145th New York Volunteers. *Courtesy of the William Floyd Estate, National Park Service.*

The regiment also known as the Stanton Legion was organized on Staten Island and mustered in on September 11, 1862. Most of its men came from New York City, but Company G included young men from the Mastic area who enlisted to serve under Lieutenant John Gelston Floyd Jr. of Floyd Manor, the former home of Declaration of Independence signer William Floyd. Other enlistees from Hempstead and Oyster Bay served in Company K. The regiment left for the war on September 27, 1862, and was initially based at Harpers Ferry in what is now West Virginia before shifting to winter quarters in Stafford Court House. The 145th was heavily engaged at Chancellorsville, losing ninety-

five killed, wounded and missing. At Gettysburg, it suffered ten casualties at Culp's Hill. The 145th was disbanded on December 9, 1863, and the enlisted men assigned to other units. During its brief service, the regiment had fifteen killed and mortally wounded in battle, with thirty-five dying of disease and other causes.

158th New York

The three-year unit was known as the First Regiment Empire or Spinola Brigade in honor of organizer Francis Spinola, a Stony Brook native who was a state senator and later a brigadier general. It was organized in Brooklyn, but Company C included men from Jamaica and Hempstead. The regiment began its service in a less than auspicious manner when recruits in the East New York barracks rioted over not receiving their bounty money in August 1862. At least one hundred of them looted the Howard House bar across the street until the police and a company of marines from the Brooklyn Navy Yard restored order. "None of the Jamaica boys were injured," the *Long Island Democrat* was pleased to report.

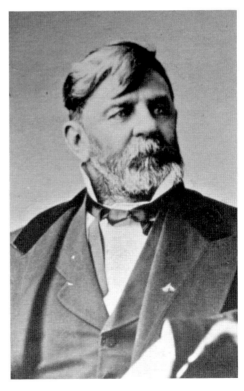

The regiment's remaining seven hundred soldiers left for North Carolina on September 18 and remained there on outpost duty and making raids until the summer of 1864, when the unit moved to Bermuda Hundred, Virginia. In heavy fighting at Fort Harrison outside Richmond on September 29, it lost seventy-eight killed, wounded and missing. Among the slain was Sergeant William Laing of Hempstead, who was awarded

General Francis B. Spinola of Stony Brook. His command included the 158th New York. *Courtesy of the U.S. Army Heritage and Education Center.*

the Medal of Honor and became the first man from current-day Nassau County so honored.

The 158th took part in the assault on Forts Gregg and Whitworth during the final attack on Petersburg on April 2, 1865. After the fall of Richmond the following day, the regiment pursued Lee's army. On the morning of April 9, it was one of the last regiments of the Army of the Potomac to fire a volley at the enemy, and it was present for Lee's surrender at Appomattox Court House later that day. The regiment was mustered out in Richmond on June 30. Its loss during the war was fifty-one killed or mortally wounded and eighty-three dead from disease and other causes.[43]

165th New York

The regiment—also known as the Second Battalion, Duryée Zouaves—was mustered in between August and December 1862 for three years' service. The men were recruited primarily in New York City and Brooklyn, but several companies included Long Islanders, among them George Cogswell of Jamaica and Samuel Dare of Selden. The unit was assigned to New Orleans. After several skirmishes, the 165th was heavily engaged in the siege of Port Hudson, with large losses in the assault of May 27, 1863.

The regiment took part in the Red River expedition in the spring of 1864, with forty-eight casualties at Sabine Crossroads and forty-nine at Pleasant Hill. Returning north, it saw action at Berryville, Virginia, in September with no casualties. It was mustered out at Charleston, South Carolina, on September 1, 1865, having lost forty-six killed and mortally wounded and eighty-one dead from disease and other causes.

176th New York

The "Ironsides Regiment" was organized in Brooklyn by the Young Men's Christian Association of New York late in 1862 for nine months' service and the following year reorganized as a three-year unit. Its volunteers included men from Oyster Bay and Southampton. After encamping in Jamaica, the Ironsides left January 11 for New Orleans, where they helped defend the city against a Confederate advance. At Brashear City, more than 400 of its men were captured. In the spring of 1864, the unit took part in the Red River Expedition in Louisiana before moving north to the Shenandoah

Valley, fighting at Opequan and Cedar Creek. In January 1865, the men joined General William T. Sherman's Carolinas Campaign. The 176th was mustered out at Savannah on April 27, 1866, having lost 33 killed and mortally wounded, with 181 dead from disease and other causes.[44]

CAVALRY

Second New York Cavalry

More than 100 Queens men joined the regiment popularly known as the Ira Harris Light Cavalry, including 40 from North Hempstead and 124 from Oyster Bay, making the Second New York the unit chosen by the most men from that town. Some may have been enticed by the regiment's recruiting ad in local papers, trumpeting "Never Walk When You Can Ride." The Second was organized in Scarsdale in Westchester County and mustered in between August and October 1861 for three years' service. It was named in honor of U.S. senator Ira Harris of New York, who had raised six of its companies. The horsemen were recruited in New York City, Long Island, upstate New York, New Jersey, Connecticut, Vermont and even Indiana. All the volunteers were experienced riders, and most brought their own horses. The companies left for the war in September and October 1861.

Encouraged in part by bounties of seventy-five dollars from Queens County and twenty-five dollars from the town, many local young men enlisted on August 13, 1862, in Company M, with more signing up on the eighteenth as well for Company C. They included lawyer Obadiah Jackson Downing of East Williston (see story on page 75), gentleman farmer Robert Stuart of Roslyn, carriage maker Jacob Mott Maybee of East Norwich, starch maker Henry Duryea of Glen Cove and farmer John Wansor of Locust Valley. Painter Josiah Brownell of Glen Cove survived the horrors of Andersonville prison camp in Georgia; Daniel Lewis Downing, son of Oyster Bay town supervisor George S. Downing, was killed.

The best record of life in the Harris Light comes from Daniel Isaac Underhill of Oyster Bay Cove, who worked as a clerk in the family business in New York City. Shortly after he enlisted, he was promoted to corporal and a month later was promoted again to sergeant, so that by the end of 1862, he was in charge of forty troopers. Transcriptions of many of his letters are in the collection of the Oyster Bay Historical Society, and as with letters from most soldiers

during the war, Underhill constantly requested clothing and other items, particularly food to complement the army's monotonous offerings. Underhill appears to have received all the items requested, including carte de visite photographs of his family and an album to keep them in. "Just what I wanted," he gushed, "I would not take a Virginia farm for it and what it contains."

The horsemen arrived in Washington on August 22, 1862, and soon skirmished with Confederates and conducted a raid into Virginia. Underhill's first letter, written on October 11, 1862, from camp at Balls Cross Roads, Virginia, tells of one of these raids:

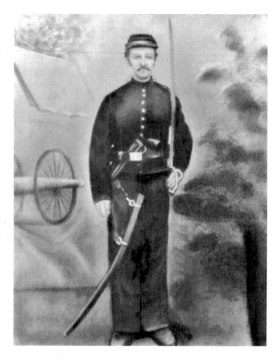

Private John Wansor, Second New York Cavalry. *Courtesy of Oyster Bay Town Historian John Hammond.*

"A long march of 150 miles in three days…We expected to have a small fight but…we marched all through that part of the Country but did not see a nary a Reb. We did not have over eight hours sleep in all. I felt very tired the last day."

Much of Underhill's duty as a sergeant was to oversee unloading of supplies that came up the Rappahannock River by barge. He wrote from Brooks Station, Virginia, on December 9, 1862, to say that although there was no major fighting with the Confederates across the river,

it is rather dangerous standing picket…There's been quite a great many of Union Calvary men taken prisoners with in the last two weeks…We live very gay when on picket. We have plenty of chickens sheep pig goose corn meal & and we make jonny hoe cake. We bake in a pan. My mustache is getting very long…It gets between my teeth when I am eating.

On December 13, as Army of the Potomac commander Ambrose Burnside attempted to dislodge the heavily entrenched Confederates at Fredericksburg, the Second New York moved down the river to Falmouth on the north bank and crossed a pontoon bridge to the battlefield. "There we layed all day and night," Underhill reported.

> *There was very heavy fighting all day the whole length of the line. I tell you the shell and bullets did whistle over our heads like the devil. I was not frighten…I tryed very hard to see them* [the shells] *when they pass over but could not. I could see them when they exploded. Our regiment was not in any action but we wer just as much exposed. I was not sorry when we wer ordered back acrosst the river.*

The regiment tangled with General J.E.B. Stuart's Confederate cavalry at Brandy Station, Virginia, on June 9, 1863, and again a week later at Aldie, losing 14 men, including Daniel Downing. After engaging in battles from Gettysburg to Appomattox Court House, the regiment was mustered out in June 1865 at Alexandria, Virginia. It had lost 74 killed in action, 49 dead from wounds and 249 succumbed to disease and other causes.[45]

Sixth New York Cavalry

The Second Ira Harris Guard was organized in the fall of 1861. In its ranks were a number of boys from eastern Suffolk, including several from Good Ground (now Hampton Bays) who enlisted at a recruiting rally at the Methodist church there. The regiment left New York on December 23, 1861, and participated in all the major cavalry battles of the Army of the Potomac. On the third day at Gettysburg, Alonzo Foster of Good Ground saved the regimental flag from capture by grabbing it when the color-bearer was killed. His heroic action is commemorated in bronze on the regimental monument on the East Cavalry Battlefield; Foster posed for the sculptor.

Following Gettysburg, the Sixth was heavily engaged at Culpeper, Cold Harbor, in General Philip Sheridan's Trevilian Raid and Bunkerhill, Virginia, finishing its service at Appomattox Court House in Virginia, where Robert E. Lee surrendered. During its tour of duty, the regiment saw 54 troopers killed in action, 28 die from wounds and 133 killed by disease or other causes.[46]

Eleventh New York Cavalry

The regiment also known as Scott's Nine Hundred was organized on Staten Island, and its companies mustered in there for three years' service between December 1861 and October 1862. The enlistees included men from Southampton, Bridgehampton, Quogue and Coram serving in Company E. The unit was initially assigned to Maryland and Virginia, where, in June 1863, it was heavily engaged at Bolivar Heights. Early in 1864, it was transferred to Louisiana, suffering 97 casualties outside Baton Rouge in September. The following year, the regiment was sent to Tennessee, where it saw its final combat on April 18. The regiment was mustered out on September 30, 1865, at Memphis. During the war, the regiment had 23 killed in action or dying of wounds and 321 dead from disease or other causes, including drowning when the transport *North America* sank off the coast of Florida on December 22, 1864.

ARTILLERY

Roemer's Battery L, Second New York Artillery/ Thirty-fourth Independent Battery

The nucleus of this unit, recruited in Flushing and College Point, was the artillery company of the Fifteenth Militia. Known initially as the Flushing Battery or Hamilton Light Artillery, it was mustered in for three years on November 28, 1861, and was the only unit of light, or horse-drawn, artillery raised on Long Island. The battery, under the command of Brevet Major Jacob Roemer of Flushing, became the most widely traveled of Long Island's Civil War units. Over four years, Roemer's Battery was engaged at Cedar Mountain, Virginia; Second Manassas; Antietam; and Fredericksburg in 1862 and the siege of Vicksburg, Mississippi, in 1863. Redesignated the Thirty-fourth Independent Battery, the unit took part in breaking the siege of Knoxville, Tennessee, in late 1863 and the next year in the Battles of the Wilderness and Spotsylvania, where Roemer's six guns were confronted by ten Confederate cannon and were about to be driven off the field until Roemer rallied his men: "I asked them one and all Boys is that so that you cannot hold your position? This will be the first time [that Battery L would] give in on the battle field. It cannot

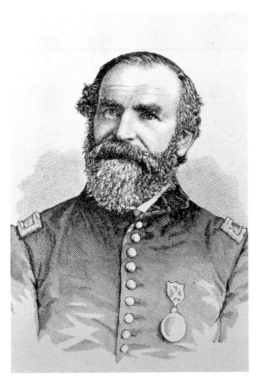

Major Jacob Roemer, Battery L, Second New York Artillery. *From Roemer's* Reminiscences of the War of the Rebellion.

be so you have been on too many hot places and you must stand this 10 minutes longer and the day is yours." His men kept firing, working the guns from their knees or on their backs because of the heavy fire coming their way, until the Rebels withdrew.

The battery continued fighting through the drive toward Richmond, engaged at Cold Harbor and taking part in the siege of Petersburg. Four members of Roemer's Battery were awarded the Medal of Honor, a record unequalled by any Long Island unit. Sergeant John H. Starkins of Flushing was recognized for bringing off his gun without any loss at the Battle of Campbell Station, Tennessee, on November 16, 1863. Sergeant Valentine Rossbach of Flushing "encouraged his cannoneers to hold a very dangerous position, and when all depended on several good shots [his piece caused] the enemy's fire to cease…thereby relieving the critical position of the Federal troops" at Spotsylvania on May 12, 1864. Private Carl Ludwig of College Point inflicted serious damage on the enemy and brought his piece from the field despite intense shelling at Petersburg on June 18, 1864. And Private Richard Beddows of Flushing retrieved the battery's guidon flag under devastating fire "after he had lost it by his horse becoming furious by the bursting of a shell" at Spotsylvania on May 18, 1864. His medal was donated in 2008 to the New York State Military History Museum in Saratoga Springs, where the guidon he rescued is preserved.

Following Lee's surrender, the veterans returned to a hero's welcome in Flushing on June 7, 1865, and were mustered out two weeks later. Roemer

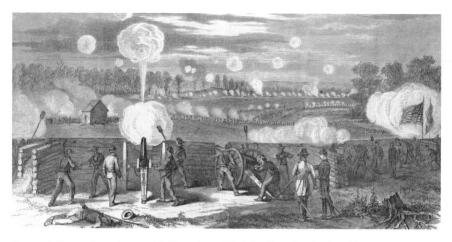

Roemer's Battery in action outside Petersburg, Virginia. *From the collection of Harrison Hunt.*

summarized the unit's history: "The Battery took part in fifty-seven different engagements, had travelled 18,758 miles, thrown from its guns over fifty-six tons of iron; [employed] 271 enlisted men, of whom [22] gave their lives… and it lost 307 horses."[47]

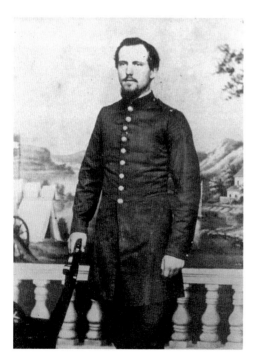

Private Sylvester Carman, Fifth New York Heavy Artillery. *Courtesy of the Nassau County Photo Archives.*

Fifth New York Heavy Artillery

The eight companies of the unit, also known as the Second Regiment Jackson Heavy Artillery, were mustered in by April 1862. The men were recruited principally in New York City and Brooklyn, but a contingent came from Hempstead, among them Asa Smith of Freeport and Sylvester Carman of Uniondale. After manning forts ringing New

York Harbor, the unit transferred to Baltimore in late May, serving in the defenses of Washington and at Harpers Ferry. Some men were detailed as infantry late in the war; one, Joseph Mott of Freeport, was captured and died in North Carolina's Salisbury Prison. On July 19, 1865, the regiment was discharged at Harpers Ferry after having 98 killed by wounds; disease and other causes claimed another 294.[48]

Sixth New York Heavy Artillery

The regiment also referred to as the Anthony Wayne Guard was mustered in on September 2, 1862, with volunteers including Suffolk men, among them Daniel Hallock of Northville. It initially served in Baltimore and at Harpers Ferry. In 1864,

it saw action in the Battles of the Wilderness, Spotsylvania and Cold Harbor; General Philip Sheridan's Shenandoah Valley Campaign; Petersburg; and the pursuit of the Army of Northern Virginia to Appomattox. The Sixth was mustered out near Washington on August 24, 1865, having lost 135 killed in battle or mortally wounded and 281 killed by disease or other causes.

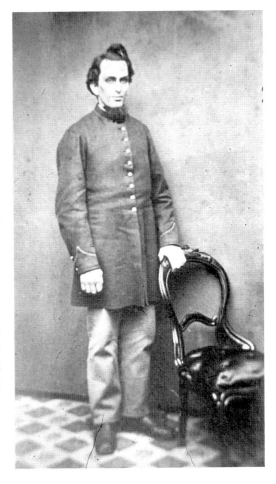

Marine Artillerists

This unit was organized to serve as gun crews on Union gunboats. For a time, its service status was in limbo:

Private Daniel Hallock, Sixth New York Heavy Artillery. *Courtesy of the Hallockville Museum Farm.*

the army and navy each thought the men belonged in the other service. Among its enlistees were twenty-five men from Sag Harbor. They served on ships such as USS *Picket*, included in "The War at Sea" chapter.

Fifteenth New York Engineers

This regiment, also known as the New York Sappers and Miners, was organized at Camp Morgan in Willets Point and included men from all over the state, including a large contingent from Newtown. It was mustered in on June 17, 1861, for two years' service. The unit built bridges and roadways, playing a particularly significant role in the Battle of Fredericksburg, when the engineers constructed pontoon bridges into the city under heavy fire. The unit was mustered out in Washington in June and July 1865, having lost 5 killed in action or from wounds with 124 dead from disease and other causes.

Berdan's Sharpshooters

Several Babylon residents with keen eyes and steady hands joined the famed First Regiment United States Volunteer Sharpshooters, better known as Berdan's Sharpshooters. The unit formed in November 1861 and played a significant role on the second day at Gettysburg. Joining the regiment required passing a demanding marksmanship test, given at Jamaica and other locations: "No man would be enlisted who could not put ten bullets in succession within five inches from the center at a distance of six hundred feet from a rest or three hundred feet off hand."

Southold native Albert Corwin served initially in the First Minnesota Infantry, having moved to that state with his parents in 1860 and enlisting at age twenty-four. In 1862, the carpenter became a member of the Second Regiment United States Volunteer Sharpshooters, formed at the same time as the First Regiment with marksmen primarily from New Hampshire, Vermont, Maine, Pennsylvania, Michigan and Minnesota. In May 1862, Corwin wrote from Fort Snelling in Minnesota that his new regiment was about to leave for Virginia, and "it seems by the present prospects that the war is nearly ended, if such is the case my services will be of short duration." But he would find himself fighting at Fredericksburg and then in a series of other battles, including Second Bull Run; South Mountain; Antietam,

where Corwin was wounded; Chancellorsville, where Corwin was captured; Brandy Station; the Wilderness, where Corwin was wounded for the second time; and Petersburg. He survived to return to Long Island, marry in 1870 and live in Peconic. In 1912, Corwin was awarded a federal pension of thirty dollars per month.

SPECIALISTS

Lieutenant William Cogswell of Jamaica was one of the first officers trained for the U.S. Signal Corps. General William H. Ludlow from Islip helped run the army's prisoner exchange system.[49]

Early Signal Corps officers in training at Georgetown, D.C. Lieutenant William Cogswell is standing third from the left. *Courtesy of the U.S. Army Heritage and Education Center.*

General William H. Ludlow. *Sketch by Alfred Waud. Courtesy of the Library of Congress.*

Obadiah Jackson Downing: At Many Battles, Ford's Theatre

Obadiah Jackson Downing was present at critical locations at crucial moments during the Civil War.

Born on April 12, 1835, in what is now East Williston, Downing managed stores in Illinois for his uncle before returning to Long Island to farm and study the law. At age twenty-six, he enlisted as a second lieutenant in the Second New York Cavalry in 1862 and fought in about 130 battles and skirmishes, including Second Bull Run, Cedar Mountain, Fredericksburg and, on June 9, 1863, at Brandy Station, Virginia, the largest cavalry engagement ever fought in North America. Lieutenant Colonel Henry Davies Jr. of the Second wrote in his official report:

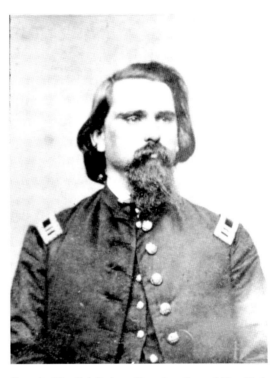

Captain Obadiah Jackson Downing, Second New York Cavalry. *Courtesy of the Nassau County Photo Archives.*

Captain Downing, of the Second New York Cavalry, who being cut off, with 50 skirmishers, at Brandy Station, charged through a column of rebel cavalry and then through their infantry, and though hotly pursued and cut off from crossing the Rappahannock at Kelly's and Ellis' fords, succeeded in making his way over Richards' Ford, and the following day he rejoined his regiment, bringing in his entire command.

Promoted to captain, Downing was captured in May 1864 during a raid on Richmond. He escaped twice but was recaptured both times; he was paroled on February 22, 1865. He joined the staff of General George Armstrong Custer and was mustered out on June 23, 1865, in Alexandria, Virginia.

Downing was in the audience at Ford's Theatre in Washington on April 14, 1865, when Abraham Lincoln was shot. He claimed to have helped carry the mortally wounded president across the street to the boardinghouse where he died. In 1922, when he was eighty-seven, Downing wrote a statement still owned by his family: "I witnessed the assassination of President Lincoln. Col. Cook and I took some captured flags to Washington and attended Ford's Theatre on that memorable night. I was one of five who helped carry his body across the street." Lincoln assassination historian Michael W. Kaufmann states that while "I can't prove that Captain Downing really helped carry Lincoln across the street…he served honorably and deserved the benefit of the doubt."

After the war, Downing returned to Long Island and was elected in 1866 to a term in the assembly. He moved in 1867 to Dixon, Illinois, where he owned two farms and married, fathering four children. He died in Dixon on July 6, 1925, at age ninety.

Downing made a symbolic homecoming of sorts with the 2005 purchase by the Society for the Preservation of Long Island Antiquities of items owned by the cavalryman—a Tiffany presentation sword given to Downing by his troopers, his cavalry saber, officer's sash, commissions and portrait—from Robert D. Cecil of Dixon, Downing's great-grandson.[50]

The War at Sea

With Long Island's maritime heritage reaching back to its earliest settlement, it's not surprising that hundreds of young men from Queens and Suffolk opted to enlist in the navy and the U.S. Revenue Service, the forerunner of the U.S. Coast Guard. They took part in all the major naval engagements of the war, manned transports, protected coastlines and guarded merchant shipping from Confederate raiders.

The outbreak of war in April 1861 had an immediate effect on Long Island's maritime industry. The numerous merchant ships that had carried cargo between New York and the South lost all of that business with the first shot fired at Fort Sumter. Any vessels in Southern waters were lucky just to return to their home ports. Captain Charles Hudson of Patchogue claimed that he got out with the last cargo of cotton headed north before hostilities erupted. The passenger ship *Glen Cove* was not as lucky; in Virginia when the war erupted, it was seized and converted into a gunboat in Norfolk Harbor, only to be burned by Union sympathizers.[51]

On the positive side, the coming of war put an end to some highly illegal commerce between Long Island and the Southern states. For years, local vessels had been sold to Southern owners for the surreptitious importation of slaves from Africa, which had been illegal in the United States since 1807. Among them were the ships *Romulus* and *Augusta*, which were refitted for the slave trade after their days as whalers, and the smaller sailing craft *Early Bird*, built in Northport, and *Marion* and *Montauk*, both of Sag Harbor. In a low point of Long Island history, the last slaver launched in the United

States, the schooner *Wanderer*, was constructed in East Setauket. *Wanderer* was built as a pleasure yacht at Joseph Rowland's shipyard in 1857 for Colonel John Johnson of Louisiana, who had a summer home in Central Islip. The following year, Johnson sold the vessel to a man from Charleston, South Carolina, who had Rowland add large water tanks and make other alterations to suit the ship to its new use. *Wanderer* then sailed to Africa, where it took on a cargo of 497 enslaved Africans; 407 of them made it to Georgia to be sold. Only the war put a stop to *Wanderer*'s forays, when it was seized by the navy at Key West in 1861.[52]

Illegal slavers were not the only vessels concerned about being captured during the war. The Confederacy deployed a number of privateers whose mission was to disrupt Union trade and seize cargoes of value to the South, and some of these raiders preyed on shipping as close as eight miles off Montauk Point. The schooner *Thomas Potter* of Greenport narrowly eluded capture by the privateer *Jefferson Davis* in that area in 1862. *Mary Gardiner* of Sag Harbor and other ships were able to bluff their way past Confederate ships by flying English or Brazilian colors, but not all local craft were that fortunate. *Jefferson Davis* snared the Brookhaven-based coastal schooner *S.J. Waring* in July 1861 (see Chapter 5 for more about the *Waring* incident), and CSS *Florida* robbed and burned the schooner *Aldebaran* of Setauket in early 1863. A year later, the merchant ship *Margaret Y. Davis* of Bellport was seized and put to the torch by the famous Confederate raider *Alabama*, which left the captured craft's captain, Jeremiah Robinson of East Patchogue, ashore at Nassau in the Bahamas to make his way home. These were costly losses, as the owners of these vessels never received compensation. Sag Harbor whaling ships were also prime targets. *Myra* managed to elude *Alabama* off Cuba in 1862; it went on to become the last of Sag's whaling ships, going on its last voyage in 1871. Half a world away, the Confederate raider *Shenandoah* unsuccessfully pursued *Jirah Perry* during the Confederate ship's devastating campaign against the North's Pacific whaling fleet in 1865.[53]

Other Sag Harbor whaling ships played a part in one of the more unusual naval exploits of the war. In December 1861, in an effort to close Charleston Harbor, the Union purchased several old whalers, filled them with rocks and scuttled them at the entrance to the port. Among this "Stone Fleet," as it was called, were *Timor* and *Emerald* from Sag. Unfortunately, the experiment failed; the tides soon cut a new channel past the sunken ships, and Charleston's port remained open until the city's surrender in 1865.

Old whalers were not the only civilian ships utilized by the federal government during the war. The navy, unprepared for the huge task

The schooner *S.J. Waring*, captured by a Confederate raider early in the war. *From* Harper's
Weekly, August 3, 1861.

before it in 1861, quickly hired or purchased just about anything that
could float to meet its need. The Long Island Sound passenger vessels
Arrowsmith, *Flushing*, *Glen Cove* and *Long Island* were hired as troop
transports and hospital ships, as was *Massachusetts* from Sag Harbor. In
addition, Captains Charles Hudson and Henry Gillette of Patchogue
and Alanson Dickenson of Rocky Point were engaged to pilot similar
transports from other locations. Some ships were purchased outright
and outfitted as gunboats, including the sound steamer *New London* and
several ferryboats from Brooklyn.[54]

The navy's needs were soon being addressed at shipyards across the North,
and Long Island can boast of two of the most important. The Brooklyn

The whaling ships of the Stone Fleet being sunk in Charleston Harbor. *Courtesy of the U.S. Army Heritage and Education Center.*

Navy Yard in Greenpoint was one of the largest shipbuilding facilities in the country and during the war constructed, outfitted or repaired more than four hundred vessels for the navy. During most of this time, the yard was supervised by Rear Admiral Hiram Paulding of Huntington.[55]

The second significant naval facility was the Continental Iron Works, also in Greenpoint. It was here that one of the most important vessels in maritime history was constructed: inventor John Ericsson's USS *Monitor*, which was launched in January 1862. After being outfitted and tested at the navy yard, it was sent to Virginia just in time to stop the Confederate ironclad *Virginia* (formerly USS *Merrimack*) in its devastating attack on the Union fleet at Hampton Roads, the bay between Norfolk and Hampton. The historic events of March 9, 1862, were witnessed by John Mara, a young soldier from Flushing, who described them in letters to his mother published in the *Flushing Journal*:

> *Ericson's* [sic] *Battery* [USS *Monitor*] *chanced to come up that night…
> and was ready for the* Merrimac *that morning. So they both pitched into
> it…about eight o'clock, and fought until two in the afternoon. There was the
> hardest tugging I ever saw. They both ran up to one another and fired, then
> they would push out and manœuvre around like Sayers and Heenan* [two

famous boxers], *waiting for a chance at each other. All the Captains around here said it was the greatest sea-fight that was ever known. If it were not for the [Monitor]…I think she would have gone down to New York and shelled it and Brooklyn.*

With the new ship's abilities proven in combat, Continental Iron Works proceeded to construct three other monitors of slightly modified design: *Catskill, Passaic* and *Montauk*.[56] *Catskill* and many other navy ships were manned in part by recruits from Long Island. At least 250 local men served in the navy during the war and another 50 in the revenue service. These estimates are low; many sailors were not credited to the towns from which they came. Smithtown town records, for instance, reveal that "in every expedition by water Smithtown boatmen are found, but in the first year of the war they were not enumerated." Those who served in the navy were assigned to a wide variety of ships; a list of the eighty-one known vessels on which Long Islanders served can be found in the Appendices. A few were old-fashioned sailing vessels, but most were state-of-the-art ironclads and other steamships. The vast majority were employed in the Union's effort to strangle the South by blockading its ports. Scores were assigned to patrol the waters from Virginia to Florida and along the Gulf Coast—among them the former slaver *Wanderer*, which spent the war off the Florida coast after being seized by the navy. Over the years, these ships captured dozens of blockade runners trying to carry cotton, tobacco and other crops to the West Indies and Europe or return with military supplies.

Other ships, including *Neptune, Sonoma, Tallapoosa* and *Vanderbilt*, were assigned to guard American merchant vessels from Confederate raiders such as *Florida* and *Alabama*. In one of the most celebrated engagements of the war, on June 19, 1864, USS *Kearsarge* trapped and sank *Alabama* off the coast of Cherbourg, France. Among those manning *Kearsarge*'s guns that day was Joachim Pease, an African American seaman from Long Island. (For more about Pease, see Chapter 5.) Concern with Confederate raiders extended to the Pacific coast as well; the sloop-of-war *St. Mary's*, commanded by Oscar Stanton of Sag Harbor, was one of the ships that safeguarded merchant shipping in that area.[57]

Long Islanders participated in almost all the other major naval battles of the war as well, doing their part in the capture of New Orleans; Vicksburg, Mississippi; Mobile Bay, Alabama; Wilmington, North Carolina; and other ports. Two ships with local sailors, USS *Hunchback* and USS *Whitehead*,

USS *Whitehead. Sketch by Alfred Waud. Courtesy of the Library of Congress.*

were integral in the attempt to capture Franklin, Virginia, on October 3, 1862. When the boats were blocked by barricades and sustaining a terrible pounding by Confederate guns on shore, Edwin Smith, a seaman from Jamaica, swam from *Whitehead* to the shore with a rope, helping to save the ship and earning a Medal of Honor.

The most serious incident involving Long Island sailors occurred on the gunboat *Picket* on September 9, 1862, while it was on duty in the Tar River guarding Washington, North Carolina. When Confederates mounted a surprise attack against the town, *Picket's* commander, Lieutenant Sylvester Nicoll of Shelter Island, attempted to fire on them, but the ship exploded and sank. Among the eighteen killed were Nicoll, William Chester and two other men from Sag Harbor.[58] The *Corrector* eulogized "the lamented Capt. Sylvester Dering Nicoll":

> *He had received the command of a vessel before he was 30 years of age—had made many circuits of the globe, and voyages in distant seas, and had more escapes from death by storm, shipwreck and disease then falls to the lot of most men—to perish by the explosion of the magazine of his vessel,*

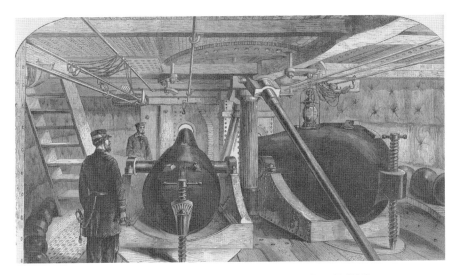

The Dahlgren guns aboard USS *Montauk*. *From* The Soldier in Our Civil War.

*while engaged in defense of the flag under which he had ever sailed, and
expressed the intention while he lived to maintain its honor. Thus perished
Capt. Nicoll, in the prime of manhood.*

Almost fifty other men from Sag Harbor opted to join the revenue service.
Most were assigned to the cutter *Agassiz*, which was charged with protecting
the ports of Sag and New London, Connecticut, for the first years of the war.
In 1863, it was sent to assist with naval operations off the North Carolina
coast. The cutters *Crawford*, *Nemaha* and *Naugatuck* were also dispatched to the
Confederate coast bearing local crewmen. The ironclad *Naugatuck*, however,
ended up spending most of the war guarding the access to New York Harbor
between Queens and the Bronx off Throggs Neck. This strategic point was
planned to be guarded by a fort being constructed on adjacent Willets Point
in Queens. However, work on the facility—now known as Fort Totten—was
stopped in 1864 after advances in naval armament proved that traditional
masonry fortifications were no longer secure. Today, visitors there can see
blocks of granite left just as they were when the masons were dismissed 150
years ago.[59]

USS *Montauk*, the one naval vessel named for a place on Long Island,
finished the war with two historic assignments: it was the secret site of John
Wilkes Booth's autopsy and a floating prison for most of his co-conspirators
in the Lincoln assassination before their executions.

Today, there are few visible reminders of Long Island's role in the navy and revenue service during the Civil War. One, a war memorial in Freeport, is a gun from USS *Hartford*, the ship on which Admiral David Farragut famously ordered, "Damn the torpedoes," during the capture of Mobile Bay. Another less obvious commemoration is the bell from the original Wantagh firehouse, on display outside the current fire department headquarters; it bears the inscription from its first use—as the ship's bell of the Civil War gunboat USS *Pinola*.

African Americans and Native Americans Aid the War Effort

No Long Islanders had a more personal stake in the outcome of the Civil War than the 5,200 African Americans who lived in Queens and Suffolk. Although free, they all were deeply aware of what slavery meant for their race. During the course of the war, at least 250 African Americans from Long Island volunteered to fight.

When the war began, there were 4,800 blacks living in Kings, 3,200 in Queens and 2,000 in Suffolk. Most were the descendants of the enslaved workers of Dutch and English colonists. Some had been born into slavery themselves; New York did not abolish slavery until 1827, and the area's African American communities included numerous men and women who had made their way from the South seeking freedom (see Chapter 1). They also knew that as long as slavery existed anywhere in the country it was a danger to them all. Ships called "blackbirders" came north to kidnap free people of color for the slave trade. These vessels were sometimes seen off the south shore of Long Island, so local African Americans ran a real risk of being snatched and sold into slavery.[60]

The capture and threatened sale of a free black on a Long Island ship led to an early war fight for freedom on the high seas. On July 7, 1861, the schooner *S.J. Waring* of Brookhaven was captured by the Confederate privateer *Jefferson Davis* 150 miles off Sandy Hook, New Jersey. The Southerners put a five-man crew of their own aboard *Waring* and took the Yankees prisoner, leaving only four of them on board to help run the vessel: two sailors, one passenger and the steward, William Tillman. An African American raised in Delaware

William Tillman (with axe) recapturing the schooner *S.J. Waring. From* Harper's Weekly, *August 3, 1861.*

and Rhode Island, Tillman was told by the Rebels that he would be sold as a slave when they reached Charleston, where he would earn them $1,000 or more. After several days, Tillman convinced the passenger and one of *Waring*'s sailors to help him take back the ship. On the night of July 16, the seemingly compliant steward, who had the run of the ship, grabbed a hatchet and bashed in the heads of the captain and his two officers. Tillman and his two accomplices were then able to turn northward, arriving at New York on

the twenty-first. His fight to recapture the ship and preserve his freedom was celebrated throughout the North.[61]

Many other African Americans wanted to fight for freedom in 1861 as well but found they were unable to enlist in the army. Northerners in general were prejudiced against blacks. Many doubted they could become good soldiers. And even some whites who thought blacks could fight effectively still didn't want to serve with them.

In addition, for political reasons, the federal government emphasized that the war was being fought to preserve the Union and was not about slavery. Seeking to avoid driving the border states into the Confederacy, President Lincoln famously declared, "If I could save the Union without freeing *any* slave I would do it, and if I could save it by freeing *all* the slaves I would do it, and if I could save it by freeing some and leaving others alone I would also do that."[62]

African Americans had a long-standing history of maritime service, however, and were welcomed as enlisted men in the navy. An estimated eighteen thousand blacks—one in five sailors—served on the integrated ships of the U.S. Navy during the war. Among them were ten men from Suffolk and an indeterminate number of others; an exact count cannot be made because most local records do not indicate the race of sailors.

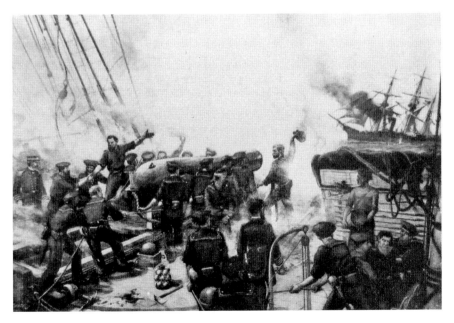

USS *Kearsarge* during its engagement with CSS *Alabama*. The African American gunman probably depicts Joachim Pease. *Courtesy of the U.S. Army Heritage and Education Center.*

One of those who served from Long Island was Joachim Pease, a twenty-year-old who enlisted in January 1862 and was eventually assigned to USS *Kearsarge*. During the famous engagement in which that ship sank the raider CSS *Alabama* off the coast of Cherbourg, France, on June 19, 1864, Pease was the loader on *Kearsarge*'s number two gun—the African American crewman with the most responsibility on the ship. He was awarded the Medal of Honor for his actions that day for exhibiting "marked coolness and good conduct and…gallantry under fire."[63]

Eventually, the army joined the navy in accepting black recruits. When the Lincoln administration announced the Emancipation Proclamation in September 1862, the issue of slavery became bound with the war effort, and African Americans were soon permitted to fight. Unlike the navy, however, blacks were segregated into units of "Colored Troops" led by white officers. Despite this, nearly 179,000 African Americans proudly served in the Union army. The initial black units accepted for Federal service were in areas of the South under Union control and predated the Emancipation Proclamation; leading the vanguard were the Louisiana Native Guards and the First South Carolina Colored Volunteers, organized in the spring and summer of 1862.

Early in 1863, the Northern states started raising African American units as well. The first was the Fifty-fourth Massachusetts Regiment, celebrated in the film *Glory*. It was authorized in March of that year and started recruiting throughout the Northeast, including in Jamaica, Queens. That month, the *Long Island Farmer* reported:

> *The recruiting business in [Jamaica] has revived again…but this time it is among the colored population. Last week two men, clothed with authority, came here from Massachusetts to get recruits for a colored regiment now forming in that state, and in a short time they obtained a half-dozen men and all of them left on Saturday for the camp in Boston.*

Five Long Island men are recorded on the roster of the Fifty-fourth Massachusetts: Elias Wilmore of Jamaica and John Green, Henry Marshall, Richard Seaman and Peter Vogelsang of Brooklyn. Vogelsang, commissioned as the quartermaster of the regiment in 1865, became one of the first black officers in the Union army. Others from Long Island, including Nathan Arch of East Hampton and several men from Jamaica and Kings, joined the Fifty-fifth Massachusetts Colored Regiment, seeing action in Florida and South Carolina. Men from Queens and Suffolk enlisted in the Fourteenth Rhode Island Colored Heavy Artillery and the Twenty-ninth Connecticut Colored

The Twenty-ninth Connecticut Colored Regiment in Beaufort, South Carolina. *Courtesy of the Library of Congress.*

Infantry. The Fourteenth Rhode Island, later redesignated the Eleventh U.S. Colored Heavy Artillery, was organized in the summer of 1863 and served guarding New Orleans and on occupation duty in Texas. The Twenty-ninth Connecticut took to the field in March 1864, participating in the siege of Petersburg, Virginia. It was one of the first Federal units to enter the fallen Confederate capital of Richmond in April 1865.[64]

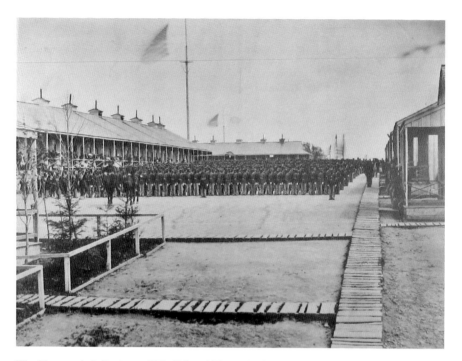

The Twenty-sixth Regiment U.S. Colored Troops in formation in Philadelphia. *Courtesy of the U.S. Army Heritage and Education Center.*

The majority of Long Island's African Americans served in the Twentieth and Twenty-sixth Regiments of the U.S. Colored Troops, which were organized at Rikers Island, Queens. Both of these units were sponsored by the pro-administration Union League Club of New York, whose members included William Cullen Bryant (see page 19) and Theodore Roosevelt's uncle James Roosevelt. The Twentieth Regiment served in New Orleans from February 1864 until it was mustered out in October 1865. During the same period, the Twenty-sixth was assigned to guard duty in Beaufort and Port Royal, South Carolina. The two regiments' ranks included four members of the Jackson family of North Wantagh, who lived in a black community there called The Brush. David, Edward, Morris and Gilbert Jackson survived the war and were interred in the Old Burial Ground that still remains where the community stood.

At least twenty-six recruits from Oyster Bay served as well. These men shared the same concerns and experiences as their white brothers in arms. David Carll, an ancestor of the actress Vanessa Williams, used the $300 bounty money he received when he enlisted to purchase property

in Oyster Bay where his descendants still live.[65] Wait Mitchell proudly filed an affidavit to vote in the 1864 presidential election, taking advantage of a wartime law that allowed adult soldiers to vote while in the field. Simon Rappalyea wrote his wife in September 1864, "I think we will get paid soon and then I will send you more money. You must keep good spirits, I think I shall get home once more." But when Rappalyea wrote about getting paid, he also touched on an issue that set him apart from white soldiers early in the days of black enlistment: he complained about receiving less pay than those in white regiments. This would lead to some African American units refusing their pay until the inequality was rectified.

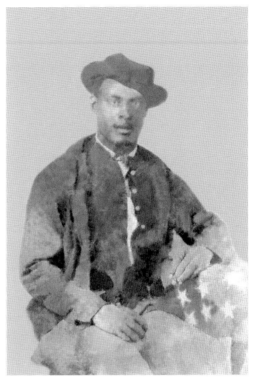

Private David Carll, Twenty-sixth U.S. Colored Troops. *Courtesy of Oyster Bay Town Historian John Hammond.*

Reflecting the racial prejudices of the day, Long Island Native Americans were forced to join colored regiments because many of their families had intermarried with African Americans, while members of upstate tribes such as the Senecas and Cayugas were permitted to enlist in white units. Among the Suffolk men who enlisted were Montaukett Stephen Pharaoh, also known as Stephen Talkhouse, Twenty-ninth Connecticut; Shinnecocks Warren Cuffee, Twentieth USCT, and Stephen Cuffee, Fourteenth Rhode Island; and Poospatuck Edward Edwards, Twentieth USCT.[66]

Not every African American who supported the war effort served as a soldier or sailor; some did their parts as civilian workers. In late 1863, several black men from Sag Harbor and the Hamptons were hired by the army to work in the South as teamsters.[67]

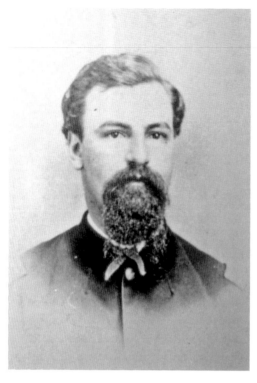

With African American units required to be led by white officers, several Long Island men volunteered for this duty, including the Reverend Smith Gammage of Patchogue, chaplain of the Seventy-fifth USCT; Lieutenant Colonel John Bogart of Southold, 103rd USCT; Captain George Sherman of Sag Harbor, Seventh USCT; Lieutenant Clement Earle of Cold Spring Harbor, Eighty-first USCT; and Huntington native George Brush, Thirty-fourth USCT. Brush won the Medal of Honor for his actions on May 24, 1864, when he organized a boat crew rescuing Union soldiers stranded in South Carolina's Ashepoo River on board the steamer *Boston*. Brush was cited for his "great gallantry…in conveying them to shore, being exposed the entire time to heavy fire from a Confederate battery."[68]

Top: John Bogart, before being commissioned lieutenant colonel of the 103rd U.S. Colored Troops. *Courtesy of the U.S. Army Heritage and Education Center.*

Left: George Washington Brush of the Thirty-fourth U.S. Colored Troops after the war. *From the collection of Harrison Hunt.*

African American soldiers and sailors helped secure the Union victory in 1865 and, with it, the end of slavery. Their service proved their worth as citizens and soldiers, earning black men equal voting rights in New York and black veterans full membership in the Union veterans' organization, the Grand Army of the Republic.

6

Life on the Homefront

It wasn't just the soldiers from Long Island who were affected by the war; its impact was felt by everyone back at home as well. Residents supported the struggle to save the Union by donating needed supplies, volunteering at hospitals and manufacturing materiel for the army and navy. And while they were doing it, they coped with four years of uncertainty and shortages through morale-building activities and Yankee ingenuity.

No sooner had the first soldiers headed south to serve their country than women across Long Island organized sewing circles and soldiers' aid societies to support them. One of the first of these groups was started by the patriotic women of East Hampton, who were soon followed by sisters, wives and mothers doing their part in Glen Cove, Flushing, Huntington, Hempstead, Sag Harbor and other communities. At first, these clubs concentrated on supplying creature comforts for soldiers in the field, items like those collected or sewn by the ladies of Matinecock in September 1861: books, towels, 26 pairs of woolen socks, 68 shirts, 103 "housewives"—small bags containing buttons, needles, pins and thread—and 112 havelocks. The latter were cloth cap covers with an extension in the back designed to shield a soldier's neck from the sun. (For an illustration of a havelock, see the painting of Private Harrison Hunt by Mort Künstler with the author biographies.) Looking ahead to the winter, other women knit special mittens that had index fingers added to the right hands so the soldiers could load and fire their muskets while wearing them.[69]

Aid societies soon turned their attention from making havelocks for healthy soldiers to seeing to the needs of the sick and wounded. After the

first battles, it was apparent that army doctors and hospitals were short on supplies and needed donations of medical stores and food. The Ladies Aid Society of Roslyn—organized by Frances Bryant, wife of editor and poet William Cullen Bryant (see page 19)—the Jamaica Soldiers' Aid Society and their sister groups began concentrating on making items such as bandages, flannel dressing gowns, sheets, pillowcases and towels. The dedication of local women is reflected in the efforts of the ladies of Northport and Vernon Valley: from the summer of 1861 until January 1862, the *Long-Islander* proudly reported, they produced "20 bed gowns, 20 quilts, 20 flannel shirts, 20 pr. drawers, 12 pr. slippers, 42 pr. wool socks, 28 pr. mittens, 1 doz. Pocket handkerchiefs, & 6 cushions." In addition to these items, sick wards were sent food easier on invalids' digestion than the army's standard hard bread and salt pork. The shipments from the Ladies' Union Relief Society of Flushing in mid-1862 are typical: farina, gelatin, cocoa, oatmeal, rice, fruit, "Iceland moss tapioca," "127 jars jelly and preserves" and "62 bottles of wine."[70]

These associations raised funds for Union hospitals as well as providing supplies. Throughout Queens and Suffolk, women held fairs, teas and other events to accumulate money for the cause: the Jamaica Soldiers' Aid Society, for example, netted $350 with a strawberry festival in Little Neck, and the ladies of Glen Cove sponsored a Fourth of July Festival, a concert and a theatrical event headlined by a Queens County native, Dr. William Valentine, who turned from medicine to become one of the first professional comedians in the country. The largest of these fundraisers was the Brooklyn and Long Island Sanitary Fair, so named because it was supporting the United States Sanitary Commission, which assisted Union hospitals during the war (the American Red Cross had not yet been organized). Held in the Brooklyn Academy of Music from February 22 until March 9, 1864, the fair was a joint effort by aid societies from across Long Island; groups either sent items to Brooklyn for sale or held their own events with the income donated to the fair. These contributions totaled $20,000.00 and ranged from Upper Aquebogue's $14.00 and Amityville's $36.01 to $1,226.00 from Sag Harbor, $2,090.00 from Glen Cove and $2,118.00 from Newtown. Added to the funds raised in Brooklyn through admissions, auctions and sales of foods, the fair netted an astounding $402,000.00 for Union hospitals.[71]

Some Long Islanders ventured beyond fundraising to volunteer at area hospitals. There were a few where they could serve locally, including the Brooklyn Hospital; Long Island Hospital, Brooklyn; an unnamed facility on the corner of Fulton and Union Streets in Jamaica; Grant General Hospital; and DeCamp General Hospital. Grant Hospital was located on the military

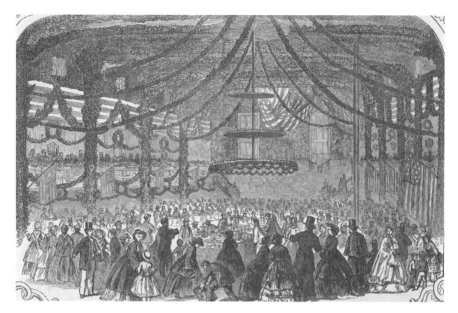

The Brooklyn and Long Island Sanitary Fair. *From* Harper's Weekly, *February 22, 1864.*

Grant General Hospital, Willets Point, Queens. *Courtesy of the U.S. Army Heritage and Education Center.*

base on Willets Point later known as Fort Totten. It operated from 1864 until June 1865, treating 5,283 Union soldiers, many of whom were ministered to by the citizens of Flushing and Bayside. DeCamp Hospital was a large complex of barracks and tents on David's Island in Long Island Sound off New Rochelle. It was easily reached by boat from Glen Cove, and the Ladies

Aid Society of that village soon developed a special affinity for the patients, as reflected in a letter sent to the *Glen Cove Gazette* in 1862:

> *The Ladies Soldiers Aid Society, accepting the services of the sloop*
> Caroline…*made a visit to the Government Hospital at David's Island…*
> *They were provided with an important cargo of wearing apparel, old linen*
> *for bandages and slings, ice cream, jellies, fruit…vegetables, eggs, blanc*
> *mange &c., &c…Could the donors of the nine or ten freezers of cream have*
> *witnessed the beaming faces of the poor sick men as the ladies dispensed it*
> *to them, they would have felt amply repaid for their trouble in preparing it.*

DeCamp Hospital treated wounded Confederate prisoners as well as Yankee boys; as the visitors from Glen Cove discovered, "in care and attention, there was no distinction shown." Occasionally, as these Rebels recovered, they would attempt to escape from the island. The story is told in Port Washington that one successful escapee was discovered by a Mrs. Cornwall in the cellar of her home near Plum Point. She was so frightened that she ran upstairs, locked the door and did not mention the incident to her husband until the next day, by which time the man had vanished.[72]

A few dedicated Long Islanders traveled beyond David's Island to volunteer as nurses close to the front. Mary Lawrence Douglass of Laurelton, Queens, wife of the Reverend Richard Douglass, served with the U.S. Christian Commission at Hospital 9 on Lookout Mountain, Tennessee, where she was reported to be in charge of the ambulance corps. Adelaide Smith of Brooklyn ministered to the wounded in field hospitals at Point of Rocks, Dutch Gap and City Point, Virginia, from July 1864 until the end of the war. Independent and strong-willed, in later years she was a well-known suffragist. One local woman actually served with the troops: Adelaide Renkens of Sag Harbor spent part of the war as a nurse with Company G of the 127th New York, her husband John's unit.[73]

Those who remained on Long Island did their part for the war effort in various ways beyond aiding the hospitals. Communities presented departing officers with swords or flags, fêted local veterans home on leave and followed the president's calls for days of thanksgiving and prayer with solemn church services. Port Jefferson artist William M. Davis derided Jefferson Davis with his trompe l'oeil painting *The Neglected Picture*, which depicted a print of Davis in a broken frame with satiric inscriptions; the painting was so popular that photos of it were sold at twenty-five cents each. And Bloodgood Cutter of Great Neck commemorated the rebellion with the remarkably bad poetry

that later caused him to be dubbed the "Poet Lariat" by Mark Twain. This sample from his piece about Captain George H. Quarterman of Flushing is typical of his doggerel:

> *I'll write some lines on my old plan,*
> *To applaud brave Captain Quarterman;*
> *Who fought so well on that bloody field*
> *Trying to make those rebels yield.*[74]

The war had both positive and negative effects on the Long Island economy. Early on, when it seemed the rebellion would be crushed in ninety days, many local shopkeepers looked on the attack on Sumter as an opportunity to offer such items as red, white and blue cravats; patriotic stationery; badges; and flags "at war prices." The true impact of the rebellion on the Northern economy soon began to be felt, however. Many merchants and investors who did business with the South were ruined. "When the bombardment of Fort Sumter began," furniture dealer Alfred Reid Sr. of Yaphank recalled, "[I left my] elegant home in the morning, a wealthy man, and came back at night penniless," having lost more than $60,000 in now uncollectable Southern debts. Earnings on nonessentials plummeted; in Bay Shore, for instance, the price of clams dropped to $1 for one thousand, devastating the local economy. To compound the problem, prices of food and other necessities increased due to the government's need for rations and a shortage of able-bodied workers. A survey by New York State revealed that the cost of farm laborers in Queens and Suffolk increased 63 percent between 1860 and 1865.[75]

Long Islanders developed some creative solutions to wartime price increases, cuts in imports and loss of trade with the South. The ladies of East Hampton found "that 'clean-chopt meadow hay' from Napeague [made] a very acceptable substitute for tea" and roasted wheat kernels good coffee. In response to the shortage of lightweight cotton, some Suffolk residents raised flax to weave linen, the last time that homespun cloth was made on Long Island outside a museum. Most surprisingly, farms across Long Island started growing tobacco during the war, with Kings producing 300 pounds, Queens 484 pounds and Suffolk an impressive 15,000 pounds in 1864.[76]

Long Island manufacturers geared up to provide needed supplies for the army and navy as soon as the war began. Cocks's gristmill in Port Washington was kept busy grinding flour for hardtack biscuits. The Perkins woolen mill in Riverhead produced a heavy water-resistant cloth prized for navy uniforms, and later in the war, a mill in Sag Harbor made cloth from

Phillipp Licht's home (left) and Eagle Fire Works factory in Ridgewood, Queens. *From the collection of Harrison Hunt.*

captured Confederate cotton. A shop in Hempstead employed women to make army jackets, seamstresses in Jamaica and Valley Stream were solicited to sew uniform trousers and merchant W.A. Conant of Huntington offered to purchase heavy wool socks "suitable for the use of the Army" from local knitters. LaLance & Grosjean in Woodhaven manufactured tin mess kits and utensils, and Conrad Poppenhusen's hard rubber works in College Point made uniform buttons, combs and other personal items for soldiers. The Benham and Stoughtenborough shop in Glen Cove fabricated tin tubes to hold artillery fuses, while Phillipp Licht's Eagle Fire Works Company in Ridgewood produced the fuses themselves. Army fifes were turned by John Firth in Maspeth, snare drums crafted by Alexander Rogers of Flushing and drum heads tanned in Woodbury by the Dowden factory, whose building still stands on West Rogues Path.[77]

Sag Harbor played an unusual role in the war effort when a new type of armament was tested there in October 1862. Three rifled guns designed by General Charles James of the Rhode Island Militia were given trials on Conklin's Point, attracting quite an audience. Unfortunately, on October 16, an explosive projectile got jammed in the largest cannon, and the twenty-four-pound shell exploded while being disarmed. The accident killed General James, two of his staff and a French army observer and wounded nine area residents in Long Island's worst incident of wartime bloodshed.[78]

The island's most significant manufacturers were the shipyards described in Chapter 4 and the laboratories that produced medicines for army and navy doctors. The U.S. Army Medical Purveying Depot in Astoria formulated and distributed medications, painkillers and dressings to regimental surgeons across the country. Major government suppliers in Brooklyn included E.R. Squibb, a forerunner of today's Bristol-Myers Squibb, and Charles Pfizer, whose firm is also still in business. Their medications would be needed more than ever as the conflict reached its climax in 1863.[79]

WALT WHITMAN, POET AND SOLDIERS' FRIEND

Walt Whitman was the most famous Long Islander to play a role in the Civil War. The poet and former newspaper editor spent the final three years of the conflict in Washington offering comfort and companionship to hundreds of wounded soldiers.

A staunch opponent of slavery who had founded the *Long-Islander* in Huntington and edited daily newspapers in Brooklyn, Whitman was living in his mother's Brooklyn home in 1862 when the name of his brother, George Washington Whitman of the Fifty-first New York Volunteers, was included in a printed list of casualties from the Battle of Fredericksburg, Virginia, on December 13. The forty-three-year-old famous author of *Leaves of Grass* left immediately for the capital. When several days of inquiries about George

Walt Whitman, circa 1860. *Courtesy of the Library of Congress.*

100

in military hospitals proved fruitless, Whitman traveled to the army camp at Falmouth, Virginia, and located his brother, who had survived an attack on entrenched Confederates with only his jaw slightly scratched by shrapnel.

After two weeks visiting injured soldiers and writing letters home for them, the poet accompanied some of the wounded being transported to Washington. He remained in the city, initially to visit the patients he had traveled with, but soon he met and helped many others during his daily visits to Carver, Cliffburne, Finley, Emory, Campbell and other hospitals. He would jot requests for letters to be written, food or candy or other needs in his notebook and then fulfill them. One day Whitman handed out ice cream in all eighteen wards at Carver Hospital. One of the soldiers he tended in August 1863 was Zachariah Hendrickson of Farmingdale, a sergeant in the 145th New York. Hendrickson knew some of Whitman's relatives, the Van Nostrands.

Whitman turned his notes from the hospital visits into articles for the *New York Times* and *Brooklyn Daily Eagle* to help pay his living expenses and provide funds for the items he gave to the soldiers. His hospital work also led to a book of poetry, *Drum-Taps*, published in May 1865, and *Sequel to Drum Taps*, printed that fall with his elegy on Lincoln, "When Lilacs Last in the Dooryard Bloom'd." He offered prose descriptions of the war in *Specimen Days & Collect* in 1882–83.

Although a controversial figure because some thought his poetry obscene, Whitman was able to get a succession of government jobs in the army paymaster's office, Department of the Interior and attorney general's office to support himself and his charity to the wounded soldiers. He was also sponsored by the U.S. Christian Commission and received donations from friends.

By war's end, Whitman estimated he had made "over 600 visits or tours, and went…among from some 80,000 to 100,000 of the wounded and sick, as sustainer of spirit and body in some degree, in time of need."

When his brother and the rest of the Fifty-first New York marched down Pennsylvania Avenue in the Grand Review of Union troops in May 1865, Whitman marched with them. He remained in Washington, working for the Bureau of Indian Affairs and again at the attorney general's office. A stroke in 1873 forced him to leave for his brother George's home in Camden, where he died on March 26, 1892, and was buried at Harleigh Cemetery.[80]

1863: The High-Water Mark and the Draft

The third year of the conflict proved to be the turning point of the Civil War. Significant defeats and critical victories, the institution of the draft in the North and the riots it spawned combined to make 1863 the pivotal period of this watershed event in American history.

The year started inauspiciously for the Union. It began with the Army of the Potomac's disastrous Mud March from January 20 to 23. Army commander Ambrose Burnside hoped to surprise Robert E. Lee's Confederates with an unusual winter attack, using pontoon bridges to cross the Rappahannock River east of Fredericksburg, Virginia, and pounce on Lee's left flank. Unfortunately, it began to rain just as Burnside's forces started to move, churning the roads into impassable mud; even more unfortunately, the hapless general did not call off the campaign for two days, destroying his soldiers' morale. Three months later, Burnside's replacement, General Joseph Hooker, allowed his forces to be flanked by Lee at Chancellorsville, Virginia, in one of the most costly Union defeats of the war.

With the Army of the Potomac once again in temporary disarray, Lee was free to begin a northern campaign. By late June, his infantry had marched into Pennsylvania, almost to Harrisburg, before turning south again to collide with pursuing Union forces at the crossroads town of Gettysburg on July 1. Long Island units were deployed in much of the battle's three days. The Fourteenth Brooklyn was among the first units engaged northwest of town; some of its men were assigned to carry the body of their corps

commander, General John Reynolds, from the field after he was killed in the opening minutes of the battle.[81]

To the northeast, the men of the 119th's Company H held their positions as long as they could, although heavily outnumbered. "We withstood an enemy more than threefold our number," Major Benjamin Willis reported,

> *receiving volleys of musketry in swift succession, and suffering severely from a destructive fire of shot and shell. Our regiment did not yield, but stood firmly until* [adjoining units] *had disappeared from the field. At this juncture, with an enemy in front and on either flank* [delivering] *a heavy enfilading fire, we retired in good order and…were the last regiment to reach…the town.*

Among those killed in the engagement was twenty-four-year-old Henry Camps, who had saved the regiment's colors at Chancellorsville (see page 53).[82]

That night, the men of the 14th Brooklyn, the 1st Long Island, the 102nd and the 145th dug in to hold Culp's Hill, on the far right of the Army of the Potomac. They drove back multiple assaults by the Confederates the following day. Also on July 2, several other units faced hard fighting on the Union left. The men of Captain Quarterman's company of the Fifth Excelsior Regiment were among the first troops to clash with Longstreet's Confederates near the Peach Orchard, in front of the main Union line. At the day's close, the company tallied 20 casualties, including Seth Harpell of Whitestone and Oliver Valentine of Hempstead killed and William Seaman of Port Washington and Wilson Moore of Freeport wounded. A bit to the southeast, the 57th New York lost 34 men trying to hold back the Rebel onslaught in the Wheatfield; Major DeLancey Floyd-Jones's 11th U.S. Regulars tallied 125 killed, wounded and missing between the Wheatfield and Devil's Den; and the Mozart Regiment suffered 150 casualties protecting the base of Little Round Top. In the evening, the men of Willis Company helped defeat the day's final assault, an attempt by General Harry Hays's "Louisiana Tigers" to capture East Cemetery Hill.[83]

Despite the day's casualties, the survivors remained in good spirits. Private Daniel Williams of Quarterman's Company, on hearing that his compatriots were out of paper to write home, volunteered to go out on the battlefield that night to find some. He not only brought in paper and envelopes but also "a ring from the finger of a rebel captain as a trophy of the battle." Taking advantage of Williams's find, Sergeant William Youngs wrote home to Flushing, "Our boys are determined to give Johnny Reb a little fire

and brimstone for his invasion of Pennsylvania, and I imagine they wish themselves back in Virginia again."[84]

On the last day of the battle, Union Cavalry including the Second and Sixth New York Regiments drove off J.E.B. Stuart's horsemen east of town, and the infantry stood fast against Pickett's Charge, spurring Lee's forces to indeed head back to Virginia, where they would remain for the rest of the war.

The second great Union victory of 1863, at Vicksburg, Mississippi, was sealed at the same time as Gettysburg. After a siege of a month and a half, Vicksburg was surrendered on July 4—and with it Southern control of the Mississippi River. One Long Island unit took part: Roemer's Battery, which had arrived on June 18 and served until the surrender. When Roemer expressed disappointment that the unit would be transferred before he could see Vicksburg, one of General Ulysses Grant's spies, whom Roemer had gotten to know, said he could get him in, and the captain had the distinction of arriving in the fallen city before his commanding general.[85]

While these victories began to turn the tide in favor of the North, the human cost of two years of warfare was tremendous: at Gettysburg alone, the 50,000 casualties on both sides over three days exceeded by 7,000 the population of Suffolk County. By mid-1863, the Union army was having difficulty replenishing its depleted ranks. Many of the patriotic young men who were willing to enlist had already done so in the months following Fort Sumter or after President Lincoln's call for 300,000 more men in mid-1862—a summons that inspired one of the most well-known songs of the war, "We Are Coming, Father Abra'am, 300,000 More." Many towns and counties offered cash bounties to spur enlistments, and businessmen like Conrad Poppenhusen of College Point pledged to support the families of men who signed up. Such efforts proved unsuccessful nationwide, and in March 1863, Congress passed a Draft Act. Under it, quotas were set for each state, and if the numbers were not met, men would be conscripted.[86]

The draft immediately proved unpopular. Those opposed to the war resented having to serve, as did men for whom it would be a family hardship. Many Irish immigrants did not want to fight because they feared freed Southern slaves would come north and undercut them for jobs if the Union won. The most distasteful aspects of the draft were provisions for evading service by hiring a substitute or paying a $300 "commutation fee." The concept of paying in lieu of being a soldier was nothing new; prewar militia service was seen as a form of tax that could be paid by labor or through a cash commutation. The objection was over the amount of the fee, which made it an option only for the well-to-do.[87]

The implementation of the draft in Manhattan on July 13, 1863, resulted in the most destructive riot in American history. For five days, mobs of poor, largely immigrant laborers ran uncontrolled through the city streets, attacking government offices and the homes and workplaces of abolitionists and the wealthy. Blacks, whom they blamed for the war, were particularly targeted; a number were lynched, and the rioters burned an African American orphanage. Blacks who could fled the city. Ruth Velsor of Westbury explained how Jim, the employee of a friend, escaped: "They got him on a cart and turned a box over him and started for the 34th street ferry and got him across and put him on horseback and told him to ride for his life."[88]

Many Long Islanders feared the mayhem that overwhelmed New York would spread and took appropriate measures. Armed patrols were established in Southampton and other locations. Residents in Huntington, fearing an uprising by Irish workers at the brickyard on Lloyd Neck, blockaded the causeway linking the communities. When someone on the Long Island Rail Road was overheard to threaten that "Bryant's house would have to blaze," the antislavery editor William Cullen Bryant sent four pistols to his staff to protect his Roslyn home, Cedarmere. In Sag Harbor, Oliver Wade distributed rifles to men in the African American enclave of Eastville to protect themselves. When word of this leaked out, Wade placed four whaling harpoon guns loaded with iron around his house and kept guard for a week. And in Flushing, the leader of the black community asked the priest at the Roman Catholic church to inform his flock that for every black killed, two Irish would be slain; they were not bothered.[89]

Unfortunately, no precautions were taken in Jamaica, where the draft office for Queens and Suffolk was located. "Timid counsels prevailed," Henry Onderdonk Jr. bemoaned, and the village fell victim to rioters on July 14, the day before the draft was to begin.

About dusk they began to gather together. Someone cried out "Now for the clothing [uniforms for the new draftees]!" The mob…rushed to the building in Washington Street…with intent to destroy it…On the entreaty of some leading Democrats [the rioters contented themselves] with taking out some boxes of soldiers' clothing, which they broke open and piled in heaps, and then set on fire. The large pile, called "Mount Vesuvius," was about ten feet high. The woolens did not readily burn, and some was carried off by Irish women for family use…The mob next proceeded to McHugh's hotel, where they drank freely and without cost.

Luckily, the upheaval lasted only one night. On hearing of the riot, the Babylon company of the Sixteenth Militia Regiment reported to Jamaica but found there was nothing to do. The Jamaica and Oyster Bay companies of the Fifteenth Regiment were placed on alert during the disturbance but were not used.[90]

The first Long Island draft finally took place on September 2 under the watchful eye of the Fourth Ohio Volunteers, which had been sent to Jamaica in August to forestall any trouble. Conscription continued until the end of the war. It remained unpopular, and while there were no more riots, it did lead to another serious incident. In the summer of 1864, Richard Smith of Coram allowed his home to be used as headquarters for the draft officers of the district, who discovered that three men from Port Jefferson—Tuthill Smith, George Hulse and George Dayton—were deserters. Angry at being arrested, the trio took their revenge on Smith the following January 25 by burning his house and barns. Smith and Hulse were found guilty of arson and sentenced to ten years in prison.[91]

After all this upheaval, the draft turned out to be of little use. Of the 2,700 names drawn in Queens and Suffolk in 1863, only 138 in Queens and 92 in Suffolk were considered for conscription; the rest were exempt for various reasons, provided a substitute or paid the commutation fee. As a result, the counties and towns started raising funds to offer bounties of up to $1,000 to substitutes from other areas—most often Brooklyn—to meet their quotas and do away with the draft altogether. The practice was costly: Suffolk's towns spent $303,600 for enlistment bounties and Queens County $1,275,380. Despite the expense, citizens were pleased with the results, as seen by the presentations made to some town supervisors at the end of the war. Hempstead's Seaman H. Snedeker was given a set of silver plate, Martin Duryea of Jamaica a silver tea service, George Downing of Oyster Bay a gold watch and John M. Clark of North Hempstead a silver tea and coffee service preserved by the Nassau County Historical Society.[92]

With the issue of additional recruits settled, the war continued, with most Long Islanders sharing the sentiments of Sergeant William Young of Captain Quarterman's Company: "We have got Johnny Reb 'where the hair is short,' and will make him squeal before we let him go."[93]

DeLancey Floyd-Jones, Regular Army Officer

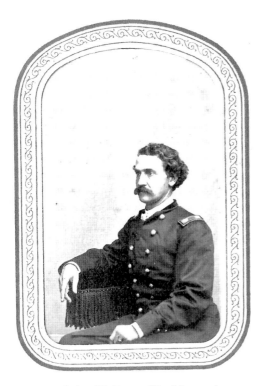

Lieutenant Colonel DeLancey Floyd-Jones, circa 1865. *Courtesy of the Historical Society of the Massapequas.*

DeLancey Floyd-Jones of South Oyster Bay—now Massapequa—was born on January 20, 1826, a member of the prominent family for which Jones Beach is named. He came from a military family: his father, Henry, and uncle Thomas were generals in the militia. He served in the regular army before the Civil War and was promoted in the field to brevet brigadier general during the conflict.

At fifteen, he enrolled in the U.S. Military Academy's class of 1846 with future Civil War generals George McClellan, Stonewall Jackson, A.P. Hill and George Pickett. In the Mexican War, Floyd-Jones was given two brevet honorary field promotions, to second and first lieutenant, while fighting in several battles, including the capture of Mexico City. After returning to the United States in 1848, he served with infantry regiments in Mississippi and Detroit before transferring to recruiting duty in 1851. Floyd-Jones scouted trails in Oregon and Washington Territory from 1852 through 1855, was promoted to captain in 1854 and in 1856 helped quell Indian uprisings in the Northwest. Then he recruited in Kansas, Philadelphia and New York before overseeing construction of a military road from the Midwest to the Pacific Ocean.

After Fort Sumter, Floyd-Jones was promoted to major and commanded the Eleventh Infantry Regiment at the Battles of Yorktown, Gaines Mill and Malvern Hill. He was named brevet lieutenant colonel on July 4, 1862, for "gallant and meritorious service during the Peninsular Campaign." He fought at the Second Battle of Bull Run, and his regiment was lightly

engaged at Antietam and was also at Chancellorsville. At Gettysburg, Floyd-Jones and his men fought near the Wheatfield and incurred substantial casualties. He was appointed brevet colonel for "gallant and meritorious service at Gettysburg." On August 1, 1863, he received a regular promotion to lieutenant colonel of the Nineteenth U.S. Infantry and was assigned to oversee recruiting at Fort Independence in Massachusetts. That October, he took command of all the fortifications around Boston Harbor and held that position until March 1865. He was brevetted brigadier general on March 13, 1865, and became commander of the Nineteenth Infantry in April 1865.

After the war, Floyd-Jones commanded barracks in Michigan and Kentucky, and then he served as assistant inspector general and judge advocate in Arkansas. After a promotion to colonel, he moved to the Sixth Infantry in 1867 as commander of Fort Gibson in Indian Territory and in 1869 was named superintendent of Indian affairs in Idaho Territory. Two years later, he transferred to the Third Infantry, remaining until his retirement in 1879.

He is best known on Long Island for his 1896 construction of the still-operating DeLancey Floyd-Jones Free Library, the first public library in the Massapequas. He died in New York City at age seventy-five on January 19, 1902.[94]

1864: The Late War and the Election

The tide of the war turned inexorably in favor of the Union in 1864, with Long Island soldiers taking part in the battles in the Southeast that doomed the Confederacy. Those military campaigns and the soldiers who fought in them would also play a decisive role in the most significant event of the year: the political campaign that allowed Abraham Lincoln to continue to guide the Union to victory.

After the president brought Ulysses S. Grant east to oversee all the Union armies, the new commander readied the Army of the Potomac to defeat Lee's Confederates, whatever the cost. An equally determined Elisha Wells of Upper Aquebogue, serving with the Second Connecticut Heavy Artillery, wrote from Alexandria, Virginia, on April 3, 1864:

> *I should like to be at the taking of Richmond; however, there will probably be a great many lives lost in this spring campaign. I expect to stick to it; I believe I am in the right, and I believe the North will conquer the rebels and give them their desserts.* [95]

Grant began his movement to capture Richmond—known as the Overland Campaign—on May 5 with the Battle of the Wilderness. Among those in the brutal fight was Josiah Brownell of Glen Cove, a private in the Second New York Cavalry. Three years later, he recalled that "along the line came the order to charge. We met the enemy first with carbines; and with our sabres and revolvers we strove hand to hand for life or death." Brownell

and sixteen other members of the regiment were captured, but he managed to survive the horrific conditions at Andersonville in Georgia.[96]

Despite staggering losses in the Wilderness, Grant, unlike his predecessors, continued to march toward the Confederate capital, heartening soldiers and civilians who supported pursuing the war vigorously. Even the Democratic Sag Harbor *Corrector* approved, declaring, "The news from Grant's army in Virginia continues to be of the most cheering character. The Union columns are steadily advancing."[97]

Many other Long Islanders besides Brownell took part in that spring's campaign, including the Bayles brothers in the 139th New York. Edward—who early in May had written, "I think General Grant will give the rebs 'Hail Columbia' this summer"—and Albert saw their first action at Cold Harbor near Richmond. After digging entrenchments around the clock for four days, Albert witnessed a devastating exchange of artillery fire:

> *It was the most terrible thing we have seen. I believe we lost about 60 or 70 and they say our men buried 263 of their dead. The sight and sound resembled a heavy thunder shower. The bursting shells on the midnight sky and the thunder of cannon with a rattle of musketry what some would call grand, I suppose. Edy is with me and we are in health, thanks be to a most Merciful Protector.*

Albert added that he understood why so few Brookhaven men seemed interested in serving late in the war. "I don't blame anyone for not wanting to come, no indeed," he said. "I know too much of this life already."

That melancholy missive would be the last written by the brothers. Eleven days later, their uncle received a letter from Captain Theodore Miller of Company A stating that the two soldiers had been killed in action at Cold Harbor on June 2. "They were brave and earnest in the work assigned to us and both fell with their face to their enemies," Miller attested. Sergeant Oscar Oakley on July 21 provided more details:

> *The order was "forward" and on those gallant troops charged…Albert was shot, the ball passing through his left arm and into the side. All that he said was "take me away." I think that Eddie would have been with us at the present time if he had not taken it as hard for the loss of his brother. He could not be kept back from him and he was killed by a sharp shooter. They were both buried in one grave.*

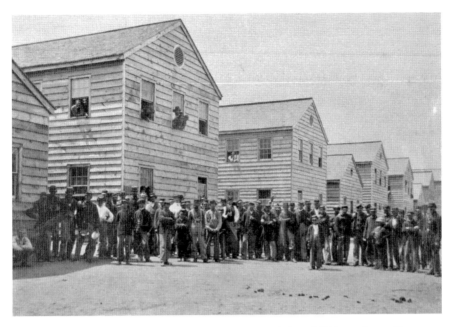

Men of the Fifteenth, Sixteenth and Seventeenth New York State Militia on duty at Fort Wadsworth, Staten Island, in June 1864. *Courtesy of the U.S. Army Heritage and Education Center.*

Their bodies remain in that grave at Cold Harbor, but a monument to them was erected in Middle Island's Union Cemetery.[98]

"Wallace" of the Eighty-first New York also described the fighting: "The Rebels repeatedly charged on our line but were…driven back with great slaughter…They fight with the reckless determination of desperate men. All night the rebels lay on the field screaming for help and moaning with agony."[99]

Grant's stunning casualties at Cold Harbor and other battles on the drive to Richmond led to a shortage of manpower that resulted in the only wartime service of the Queens and Suffolk militia outside Long Island. In June 1864, some members of the Fifteenth and Sixteenth Regiments were detailed to Fort Wadsworth on Staten Island for a month to free up soldiers stationed there to fight in Virginia.[100]

A bold maneuver begun June 12 by Grant to break the stalemate at Cold Harbor by crossing his troops to the south side of the James River surprised Robert E. Lee and brought the army to Petersburg, the back door to Richmond. Although heavy losses from the fighting around both cities would continue to mount through the following spring, the tenacity of Grant

and his army generated optimism on Long Island. "There are reasons for a more enthusiastic celebration of the Fourth of July this year than at any time since the beginning of the war," the *Hempstead Inquirer* wrote. "We may now again realize that the Fourth of July is the birthday of the nation that still lives." The planned holiday celebrations included "a swimming match for 10,000 clams" in Rockaway Beach.[101]

While the casualty counts from Grant's battles kept rising, more soldiers continued dying from disease than from wounds. Typhoid fever was one of the biggest killers, claiming a number of men in the 127th New York that July, including Stephen P. Squires of Sag Harbor and William Collum Jr. of East Hampton. "There was a great deal of sickness in camp," the *Corrector* explained. "Water bad and weather very hot."[102]

The presidential campaign took shape over the summer as well. Even before the Democrats in late August nominated General George B. McClellan on a peace platform, the central issue was whether to continue the conflict or choose peace at the price of a permanently divided nation.

The overly cautious commander sacked by the president was actively campaigning even before the convention. "Little Mac" was familiar with Long Island, having vacationed with his wife in Sag Harbor and East Hampton the previous summer. He knew that Long Island was a Democratic stronghold and made the most of a visit to Hempstead in the first week of August to see a former subordinate. A committee was formed to plan a celebration in his honor, and more than one thousand admirers from Flushing, Jamaica, Newtown, North Hempstead and Oyster Bay ignored a downpour to follow the Hempstead Cornet Band to where McClellan was staying and shake his hand.

> All along the route the procession was greeted with cheers for "little Mac," and the ladies of the village from their windows with their snowy handkerchiefs waved a hearty welcome to all. Rockets, roman candles and other fire works were set off at various points…The General spoke as follows: "I knew that the Long Island men are brave, for many of your dearest friends have gallantly fought and heroically fallen in my command. I know now, that your hearts are warm and earnest else you would not have come on such a night as this to greet one whose only claim upon you is that he loved his country."

The *Long Island Democrat* concluded that "the tone of the popular sentiment is decidedly in favor of a change" since Lincoln changed "the war for the

Union into a mere abolition Crusade."[103] Throughout the war there were some Northerners who opposed it, including Copperheads like newspaper editor Henry Reeves of Greenport and McClellan's "Peace Democrats." The peace issue had begun to be a major factor the previous summer, when the Copperheads had held a Riverhead rally. Support for a compromise to end the bloodshed was spurred by war-driven inflation, unhappiness over the draft, the Union defeat at Chancellorsville, the Emancipation Proclamation and the arrest of former Ohio Democratic congressman Clement L. Vallandigham for making a speech denouncing the Lincoln administration.[104]

While McClellan distanced himself from his party's peace platform after Sherman captured Atlanta on September 2, the Republicans worked to gain the support of "War Democrats"—the majority of the party members in the New York area—who wanted the Union preserved but frowned on abolishing slavery. But eliminating bondage was a key element of the Republican platform. "The peace platform was intended…to reconstruct the Union on the basis of slavery, and if McClellan is elected, all the blood and treasure sacrificed will be for naught," a speaker declared at a party meeting in Brooklyn.

The Democratic papers continued to fire away at the president, calling McClellan an antidote to "the imbecile and wretched administration of Abraham Lincoln" and asking whether "the white man must die that the negro may live to be his equal, his superior."[105]

In Hempstead, the nomination of McClellan "was received with cheers and music, and by the firing of cannon and explosion of rockets; Roman candles, &c." In the month before the election, the village's McClellan Club marched under a large banner it had suspended across Main Street while "a concourse of citizens, numbering from 1,500 to 2,000 from all parts of the town were present." Democratic meetings were scheduled at Newbridge and Hempstead. The Republicans were active as well. "A large and enthusiastic Union meeting was held at Manhasset," and rallies were planned for Jamaica, Flushing, Newtown, Roslyn, Hempstead, Farmingdale and East Meadow. One rally had unplanned consequences: "A four horse team in the line of procession proceeding to the Union meeting held at Glen Cove, became frightened, and ran away, running over George Kirk, a lad aged about 12 years, killing him instantly; they also ran over a Mr. Miller, and others injuring them seriously." The *Long Island Democrat* complained that "Republicans of Flushing advertised a meeting to be held at the Town Hall, and to fill up the room great pains were taken to get out the women and children."[106]

After reporting the campaign without bias, the *Inquirer* laid out its own position just before Election Day:

> *Never before has our country been in so great a strain…We are now to decide between two policies…shall the war be continued with all possible vigor, come what may, or shall we seek peace through negotiations and compromise?…We cannot believe it right or just that our Nation's flag should be either stripped of a part of its bright stars or trailed in the dust at the feet of defiant rebellion. Let us complete what we have begun with fearlessness.*[107]

The votes cast on Election Day mirrored the results of 1860. McClellan carried Queens, 5,400 to 4,284, beating Lincoln easily in Newtown, Flushing, Jamaica and Oyster Bay. Lincoln won handily in Hempstead and North Hempstead. Suffolk voters handed Lincoln a slightly larger margin than in 1860—277 votes out of 8,333 cast. Lincoln took New York State by about 8,000 votes.[108]

The vote of soldiers, who were either granted furloughs to go home to the polls or mailed affidavit ballots from their camps, was crucial to Lincoln's reelection. While members of the Flushing Battery supported McClellan with absentee ballots, the majority of those who had volunteered remained loyal to the president. Henry Prince of the 127th New York wrote, "We all rejoice over Lincoln's election. Now we will go in for finishing the rebels in the right way. I hope the Copperheads will have to close their mouths or crawl in the dirt and spit forth nothing but dust."

With the future course of the war no longer in question, Sherman continued his march across Georgia. His desire to sever the Charleston and Savannah Railroad precipitated the Battle of Honey Hill in South Carolina from November 30 until December 2. The 127th led the initial assault that failed to overrun the Rebel breastworks. One Monitor identified as "B.T.P." described a Confederate counterattack:

> *We kneeled in the grass and sent "respectful compliments" to those of our "Southern brethren" in our front, some of us paying particular attention to the flag—6th Ga.—which we afterwards captured…Many of Co. H had narrow escapes, the rebel bullets passing through different parts of their clothing, and some were slightly grazed, others hit slightly on different parts of their bodies. They were in the hottest of the fire.*[109]

When the railroad was finally severed after three days, the 127th had incurred 162 casualties.

With continuing Union successes such as Honey Hill, 1864 closed with spirits rising on Long Island, as throughout the North: "We welcome the New with new hopes and new aspirations…The Republic still lives. The old flag floats over 'repossessed' territory won by the valor of our brave citizen soldiers."[110]

1865: Surrender, Assassination and Return to Peace

Long Islanders shared the North's elation at the surrender of Robert E. Lee's army at Appomattox Court House, Virginia, on April 9 and the despair felt a week later by the assassination of President Lincoln. But their spirits rose again as the soldiers who had survived the bloodbath of the Civil War started coming home and their neighbors mobilized to welcome them and recognize the sacrifices they had made to preserve the Union.

Despite the impasse between Grant and Lee at Petersburg, Virginia, as the year opened, General William T. Sherman's progress farther south cheered residents. "The news from the South continues favorable," the *Long-Islander* reported in February. "Sherman is at work again, and is reported to be approaching Charleston from different directions…The rebel sheets at Richmond and Charleston are making a terrible outcry."[111]

After Charleston fell and the 127th New York reached the city on February 26, Sherman designated the regiment the permanent garrison unit. In one of the most symbolic celebrations of the Union victory in the war, on April 14, 1865, four years to the day after Fort Sumter had been surrendered, its former commander, now Major General Robert Anderson, returned to raise anew the same United States flag that had been hauled down at the start of the war. Proudly present for the occasion were the Monitors. "A detachment of the 127th New York and the 55th Massachusetts were drawn up in a line, presenting a fine appearance," the regimental history proudly recorded. Anderson and a sergeant "then stepped forward on the platform and unfolded the old flag, which, amid loud and enthusiastic cheering," was

raised with an evergreen wreath attached. The act was greeted by cheers, music by bands and a salute of two hundred guns from the fort and the firing of additional cannon by the fleet and batteries on nearby islands. After Anderson spoke and "The Star-Spangled Banner" was sung, the Reverend Henry Ward Beecher of Plymouth Church in Brooklyn gave an oration celebrating that "on this solemn and joyful day we again lift to the breeze our fathers' flag, now again the banner of the United States."[112]

Before it left the South Carolina city to return to New York, the 127th proved that Sherman had made the right choice in assigning the regiment garrison duty there, as seen in an article from the *Charleston Courier* reprinted in the *Long-Islander*:

> *We regret to announce to our readers that this noble regiment is under marching orders…The troops…have been on garrison duty in the city for a period of four months and over. All who have seen and known them from the moment of their entry into the city will bear witness to the gentlemanly deportment of both officers and men.*[113]

Soon after Charleston was occupied, Lincoln was inaugurated for his second term on March 4, with the *Corrector* in Sag Harbor declaring that "for this he is indebted to that unfortunate state of circumstances which has made his Administration the most important yet most painful in the history of the American Nation."[114]

As the Union armies continued their victories, prisoners of war began to be liberated. Some were fortunate, like Obadiah Jackson Downing of the Second New York Cavalry, who was reported "returned to his home in Mineola, safe and sound." Most were not, sharing the lot described in this anonymous letter to the *Long-Islander*:

> *Today I was the spectator to a sad sight—the delivery of about 400 of our brave boys who have been in the hands of the Confederate demons…Fully one half of them were unable to walk…They were many of them walking skeletons, and would stare into my face with open mouths with the gaze of an idiot. It…never will be forgotten.*[115]

April brought long-anticipated good news. "Great Victory!" the *Hempstead Inquirer* trumpeted on April 8 on the capture of Richmond and Petersburg. "On the receipt of the news in this village, flags were hoisted, cannon fired, and church bells rang, &c., &c." An official

"grand celebration" was planned for two weeks later, and "citizens of the village are requested to illuminate their dwellings on the evening of the celebration." Among the troops first entering the fallen cities were Long Islanders in the 139th New York and the 29th Connecticut Colored Infantry.[116]

There was even better news the following week when Huntington and other Long Island villages buzzed with excitement

> *on the reception of the news of the surrender of Lee and his army—the church bells were rung, guns, large and small, fired, dinner bells, tin horns, and all sorts of noisy instruments were brought into requisition, flags waved, and every body appeared jubilant and happy, except a few whose sympathies are more with the rebellion than with the government.*

A more formal gathering was being planned "to celebrate the recent Union victories, and the restoration of the national flag over Fort Sumter," with the Huntington glee club furnishing music.[117]

The upbeat news was replaced with horror, anger and sorrow a week later when Lincoln was assassinated. Even the Democratic papers that had attacked the president over four years placed black borders around their columns and offered at least backhanded compliments to the fallen leader. "All right thinking persons, no matter what their political faith may be, will regard it as the most horrible crime ever perpetuated," the *Long Island Democrat* commented. The *Corrector* printed a headline of "The National Calamity!" above its coverage of "the startling and shocking intelligence" and advised its readers to "honor the memory of the dead President whatever may be your political opinions. He dies in the hour of triumph: in the hour of his country's restored greatness. Living he might have made mistakes which the historian would have recorded; dying as he has, he dies a martyr to Liberty!"

In Hempstead,

> *the bells of all* [our]*...churches were tolled. On the Sabbath all flags were flying at half-mast and draped with black, and many of our private dwellings hung out insignia of mourning, and the people gathered to the churches as to funeral solemnities. Business was entirely suspended* [in our village]*...on Wednesday, the day appointed for the funeral of Mr. Lincoln. The stores were all closed, and the insignia of mourning was everywhere displayed.*[118]

The closest tie Long Island had with the assassination was Lieutenant Henry Brewster of Islip, originally of the Fifty-seventh New York Infantry and then serving in the Veteran Reserve Corps. He was in charge of the Potomac River bridge used by John Wilkes Booth to escape Washington after he shot Lincoln, but Brewster and his guards had no idea what had happened and allowed Booth and fellow conspirator David Herold to pass.[119]

Within weeks of the end to the fighting, local leaders were planning appropriate homecoming ceremonies for the soldiers who had survived. "Soon we trust the gallant volunteers from Jamaica will be on their way home," the editor of the *Long Island Democrat* wrote:

> *For nearly three years they have performed their part in the dangers of the conflicts, the privations of the long and tedious watches, and all the discomforts incident to a soldier's life…They will be welcomed back again with a warmth and enthusiasm surpassing the ties of kindred, and receive the gratitude and love of all who admire noble deeds and heroic conduct. Our citizens should see that these gallant men have a proper reception.*[120]

The return to their Long Island homes could not happen fast enough for the veterans. Samuel Ranger, who had enlisted with the Monitors in Greenport, wrote on May 29 that "we are to have a grand review today…I wish they would discharge us instead of review us every day or two."

After the last Confederate army had surrendered eleven days later, Ranger happily followed up that "I have sent a box by express with some of my cloes in it—you may expect me home by the forth of July if nothing happens."[121] After the soldiers of the 119th New York were discharged at Hart Island at the western end of Long Island Sound, the remaining men of Willis Company returned to their homes. The *Hempstead Inquirer* reported on June 24 that "about 30 of these soldiers arrived in this village on Wednesday evening last." The newspaper followed the item with a poem entitled "Our Boys Are Coming Home," of which two lines read: "And how our prayers are granted, Our boys are coming home!"

As would be expected, the Fourth of July took on added significance as a day for commemorating reunification and the local soldiers who had helped make that happen. "It will be celebrated and observed throughout the length and breadth of the land with more unanimity than at any previous period in our history," observed the *Corrector*, "for it will commemorate not only the birth of the American Union but its restoration and regeneration."[122]

Jamaica residents were instructed to fill the Presbyterian church by 11:00 a.m. "so that when the volunteers enter they may have a hearty 'welcome home' and they understand that his services and sacrifices have been appreciated." The service was followed by a dinner that attracted about fifty returning soldiers. The fête was highlighted by toasts for July 4, 1776, the president, the governor, the memory of George Washington, the memory of Abraham Lincoln and the army and navy and ended with "a grand and interesting display of fire-works."[123]

In Hempstead, "at sunrise, the bells of the different churches were rang, and national salutes fired in different parts of the village. At about 9 o'clock, Companies E, F and G, 89th Regiment, numbering about 100 men, were formed into line and marched to the corner of Fulton and Franklin streets, where they became the escort of about 60 returned veterans." At the ceremonies that followed, which included the reading of the Declaration of Independence, the crowd was addressed by Benjamin Willis of the 119th New York. After a dinner provided by "the Ladies of the Washington Association," the members of Willis's Company H presented him "with the flag they carried with them when they started for the war." The eventful and emotional day ended on a sour note, however; the ceremonies concluded with fireworks that were "considered a very discreditable display, and fell much short of the general expectation."[124]

There were no fireworks when the men of the 127th returned home to Suffolk in August, but there were warm celebrations. A "Soldiers Reception" in Huntington featured the requisite speeches and performances by the ubiquitous Hempstead Cornet Band and Huntington Glee Club, for which

> there was a very large attendance from all parts of the town. The large tent...was very handsomely decorated with flags and several of the Company colors of the 127th, of which a large portion of those present who had been in the service had been members. In the background or rear of the stand were portraits of Lincoln, Grant, Sherman and Sheridan...After the exercises were closed at the stand, a bountiful repast was furnished to the soldiers at tables set under the tent.[125]

In August, a picnic was held in honor of the Monitors veterans in Peconic. After speeches, prayers and the singing of patriotic songs by sixty young ladies clad in white, "the most palatable duties of the day were engaged in, some two hundred soldiers and their lady friends sitting down to tables bountifully laden with good things." The day ended with "rousing cheers for

the 'old flag'" and the singing of "Home, Sweet Home" and a song written for the occasion by the Reverend Epher Whitaker to the tune of "Auld Lang Syne." The final verses commemorate the service of all of Long Island's soldiers and sailors:

> *Secession's dead beneath your sword,*
> *And slavery in shame;*
> *The Union lives forever more,*
> *And you exalt its fame.*
> *Then welcome to your homes again,*
> *Since war and discord cease;*
> *You have subdued the rebel foe,*
> *And made a righteous peace.*
> *Your arms have saved a nation's life;*
> *We grateful own it here,*
> *And to your fallen comrades pay*
> *The tribute of a tear.*[126]

ABRAHAM LINCOLN AND LONG ISLAND

The Great Emancipator set foot on Long Island only twice.

Both of Lincoln's visits were to attend services at Plymouth Church in Brooklyn. The first occasion was when Lincoln, seeking the Republican presidential nomination, had come to New York to speak at Cooper Union at the suggestion of Henry Bowen of Brooklyn. On Sunday, February 25, 1860, Lincoln joined Bowen in worship at the church. After visiting his son Robert at school in New England, Lincoln returned to New York and attended Plymouth Church again on March 11. The draw was the church's dynamic pastor, Henry Ward Beecher, a captivating speaker and implacable opponent of slavery, as was his sister Harriet Beecher Stowe, author of *Uncle Tom's Cabin*.

Lincoln's closest connection with Long Island was an early supporter, the newspaper editor William Cullen Bryant of Roslyn, who introduced him at his Cooper Union Address (see page 19).

The new president, however, did not impress James Wallace Burke of Sag Harbor, who visited the White House in May 1861 and noted:

Abraham Lincoln as he appeared when giving his Cooper Union Address in 1860. *Photograph by Matthew Brady. Courtesy of the Library of Congress.*

When his Excellency entered, we rose to pay our respects and remained standing during the short conversation that followed. It may be a hard thing to say (I hope that its [sic] not treason,) but the president of the United States is not a gentleman. He didn't know how to behave in company; he

*is as awkward as a green school boy; he hums, haws and fidgets about,
scratches his head and picks his nose, and altogether is not an agreeable man
in society. He ventured a joke but it was too stale to repeat…Mrs. Lincoln
impressed me more favorably. She is a quiet, dignified, ladylike looking
person, pleasing in her manner, and quite good-looking. I was glad when
the awkward interview was over.*

Despite Burke's assessment, over the course of the war, "Father Abraham"
earned the respect of most Long Island residents. His assassination was met
with demonstrations of mourning and church services, and his memory
was honored by the Long Island poet Walt Whitman in his beautiful elegy
"When Lilacs Last in the Dooryard Bloom'd."

Abraham Lincoln entered into Long Island history once again forty years
later, when logs reputed to have been from his birthplace were stored in
several buildings in College Point in Queens. The wood was sold in 1906
to be reconstructed at the president's birthplace in Kentucky. The relics'
departure from the community was commemorated with pomp: "As
the procession passed the College Point Public School, the children sang
the national anthem and My Old Kentucky Home," and the logs were
photographed for posterity. They were later proved to be fraudulent.[127]

10

The Postwar Years

The War of the Rebellion was remembered by Long Islanders long after the last participants returned home. The sacrifices local soldiers and sailors made to keep the nation whole were vividly brought to mind through monuments, charitable activities, public commemorations and the presence of the veterans themselves.

The starkest reminders of the war were the soldiers' graves in cemeteries scattered across the island. During the Civil War, for the first time in modern history, embalmers followed the armies and did a brisk business at battlefields and hospitals in preserving soldiers' bodies and shipping them home for burial. The remains of scores of Long Islanders who perished in the war—like those of Alfred Walters of Farmingdale (see page 137)—were sent north for interment, their tombstones bearing mute testimony to their dedication to duty.

At the close of the war, the largest number of servicemen's graves was at Cypress Hills National Cemetery, on the Brooklyn-Queens border. A section of the private Cypress Hills Cemetery was set aside in 1862 for interments of Union and Confederate soldiers who died in army hospitals in the New York City area. Ridgewood resident William Denton recalled seeing "wagonloads of coffins" being delivered to the cemetery during the war; 3,170 Union soldiers and 461 Confederate prisoners had been interred there by 1870. These honored dead were among the first in the country to have flowers placed on their graves during the first national observations of Decoration Day (now called Memorial Day) held in May and June 1868.[128]

Decoration Day in Cypress Hills Cemetery. *From* Harper's Weekly, *June 20, 1868.*

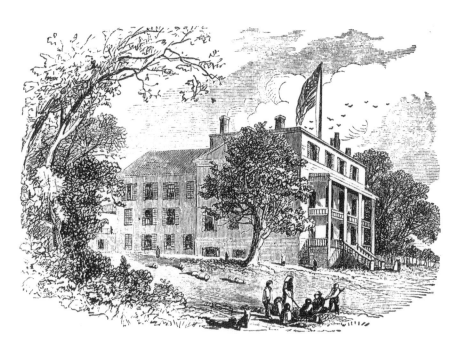

The Patriots' Orphan Home, Flushing. *From the collection of Harrison Hunt.*

Perhaps the most poignant salute to the Union's war dead in the area was the Patriots' Orphan Home in Flushing. The charity was organized in New York in 1862 to aid not only orphans of Union soldiers but also any children of deceased or disabled servicemen whose families could not care for them. In 1864, the home moved to larger quarters on an eight-acre parcel in Flushing, where it cared for more than 130 children. The institution initially received a lot of attention, including an 1864 visit by soon-to-be presidential candidate General George C. McClellan and his wife, who made a substantial donation. The home carried on its work until the end of 1871, when it closed for lack of funds and its wards were transferred to the Union Home for Soldiers' and Sailors' Orphans in Manhattan.[129]

The sacrifices made by the fathers of these children, and of all their compatriots who had served in the war, were seen as something deserving

A handbill advertising a fundraising concert for the Huntington Soldiers' Monument, February 3, 1865. *Courtesy of the Queens Borough Public Library, Archives, Broadside Collection.*

commemoration even before the fighting had ended. The earliest suggestion for a soldiers' memorial on Long Island was made by the Reverend Hiram P. Crozier in a letter to the *Long-Islander* in June 1864, suggesting a monument to Huntington men who had died in service. The idea received a warm reception, and a fundraising concert toward this end was held in Babylon (then part of Huntington town) in February 1865.[130]

Villages throughout Long Island followed Huntington's lead. Flushing was the first to erect a war memorial, an obelisk on what is now Northern Boulevard that was dedicated on July 4, 1866. Two monuments in Suffolk also constructed shortly after the war are the sandstone obelisk in Riverhead Cemetery, commemorating the war dead from that town, and a marble obelisk in Woodland Cemetery, Bellport, honoring the memories of four area servicemen whose bodies were not brought home for burial: Charles Homan, E. Thompson Cooper and Jesse Munsell of the Ninety-second Infantry and William Osborne of the Eleventh Cavalry.[131]

By the early 1900s, a variety of memorials had been constructed. The citizens of Jamaica sponsored a beautiful bronze figure of winged victory on Hillside Avenue. Granite obelisks were the choices of Orient, Northport and Greenport, while Glen Cove and East Hampton opted for simpler granite steles. Statues of soldiers in granite or bronze were erected in Southold, Patchogue, Sag Harbor, Hempstead, Newtown and Roslyn. The latter monument has had a checkered history: in the 1920s, its bronze statue's head was sawn off (and reattached), and in 1992, the entire statue was stolen from atop its twenty-foot column. It was never recovered and in 2005 was replaced with a new casting (see page 135).[132]

Huntington veterans eventually got a whole complex on Main Street, including the Soldiers' and Sailors' Memorial Building, a granite soldier statue and a huge Rodman gun. Freeport's boys in blue are also commemorated in three ways: the original public library building dedicated as a war memorial and containing a plaque listing local servicemen; a gun from USS *Hartford* on Sunrise Highway; and a memorial to Joseph and Dandridge B.P. Mott, two brothers who died in the war. This peripatetic monument was originally in the Freeport Presbyterian Church cemetery; when that graveyard was closed, it was moved to a spot near Village Hall until it was hit by a car and broken. Repaired, it is now safely on the grounds of the Freeport Historical Society.

Other noteworthy Long Island memorials include a large allegorical painting in the Poppenhusen Institute that commemorates College Point's veterans, Southampton's large pyramid of cannonballs surrounded by Civil

War artillery, a millstone on Water Mill's green displaying a plaque with veterans' names and a fifty-foot shaft topped by an eagle in Salem Fields Cemetery on the Brooklyn-Queens border erected "in memory of the soldiers of the Hebrew faith who responded to the call of their country, and gave their lives for its salvation during the dark days of its need, so that the nation might live 1861–1865." This inscription, and those on all of Long Island's monuments, makes it clear that local men had served "for the preservation of the Union," and not to end slavery.[133]

The most vivid way in which the memory of the war was kept alive was the veterans themselves. The retired generals who lived in the area were particularly visible. John Abercrombie, one of the war's older brigadiers (he was born in 1798), resided in Roslyn from 1869 until his death in 1877. Joseph Hooker, onetime commanding general of the Army of the Potomac, called the Garden City Hotel home from 1874 until he died there in 1879. Brigadier General Nathaniel McLean, who served under Hooker at Chancellorsville and later in Kentucky and the Carolinas, lived in Bellport for many years and is buried there. Major General Régis de Trobriand, who had fought valiantly at the Wheatfield in Gettysburg and continued to serve until Lee's surrender at Appomattox Court House, spent summers at his daughter's home in Bayport. He died there in 1897 and is interred beneath an impressive monument in St. Anne's Cemetery in Sayville. And Rear Admiral Hiram Paulding spent his last years in Huntington, where he ran a highly successful cider mill.[134]

Union veterans of any rank were entitled to join the Grand Army of the Republic. This fraternal organization was founded in 1866 as a way for veterans to bond, to preserve public support for the goals of the war and to lobby for better benefits for families of slain and disabled servicemen. This was a major need; in addition to those who had lost limbs or eyesight in the war, tens of thousands of veterans could not work due to what would be called post-traumatic stress today, ailments resulting from years of camping outdoors and "soldier disease"—addiction to painkillers.

Grand Army of the Republic posts were soon established across Long Island. Each was given a number and a name, usually a memorial to a deceased serviceman. The first in Queens was the George Huntsman Post #50 of Flushing, established in 1869 and named after a local member of the Fifth New York Zouaves who had been killed at the Second Battle of Bull Run. Suffolk followed in 1872 with Post #77 in Riverhead named for Henry W. Halleck, onetime commanding general of the Union army and descendant of the Hallock family of Northville. By 1892, there were ten

Members of D.B.P. Mott Post Grand Army of the Republic, Freeport, in their meeting room, circa 1900. *Courtesy of the Freeport Historical Society.*

Decoration Day parade, Hempstead, circa 1890. *Courtesy of the Nassau County Photo Archives.*

posts active in Suffolk, five in Nassau and seven in Queens. (For a complete list, consult the Appendices.) The groups held regular meetings once or twice a month and occasionally sponsored parties and picnics with the members of their ladies' auxiliary, the Women's Relief Corps. The veterans' biggest

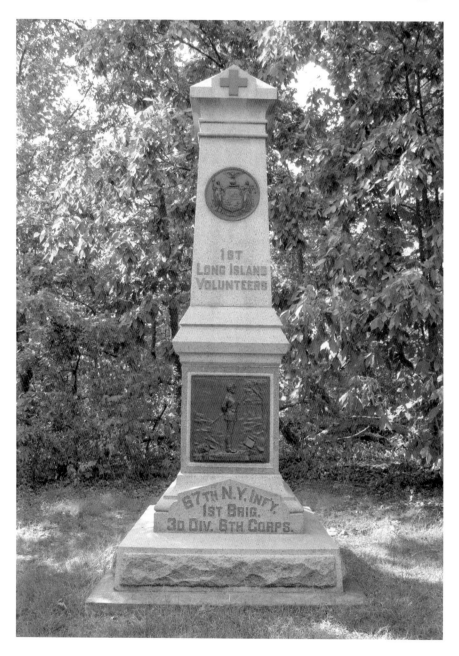

event of the year was Decoration Day in May, when the GAR units paraded through town, held ceremonies at war memorials and laid flowers at the graves of departed comrades.[135]

In addition to the Grand Army posts, members of individual units organized veterans' associations. Old soldiers from the Monitors, Willis Company of the 119th and the 2nd Cavalry were especially active, holding annual gatherings for a number of years. A special treat for some of these groups were reunions at Gettysburg around the twenty-fifth anniversary of the battle, when monuments to their regiments were unveiled. The 14th Brooklyn's was the first, in 1887; for the twenty-fifth anniversary in 1888, monuments for the 40th New York, the 1st Long Island, the 102nd New York and the 119th New York were dedicated, followed by others to the 57th New York and 145th Infantry, the Excelsior Brigade and the 2nd Cavalry and 6th Cavalry over the next four years.[136]

By the time of the fiftieth anniversary of the battle in 1913, the veterans' ranks were thinning. Over the years, there were fewer and fewer members of the GAR at Decoration Day ceremonies, and most posts disbanded in

Above: Decoration Day ceremonies, Roslyn Cemetery, circa 1915. *From the Bryant Library Local History Collection, Roslyn, New York.*

Opposite: First Long Island Regiment monument, Culp's Hill, Gettysburg. *Harrison Hunt photograph.*

Daniel Harris, last known Long Island Civil War veteran. *From the collection of Harrison Hunt.*

the mid- to late 1920s. Only a handful of Long Island's boys in blue survived until the 1940s. Finally, their ranks dwindled to just one: Daniel Harris of Ridgewood, Queens, who had been born in London, served in the navy and was also the last Jewish Civil War veteran in the country. Harris passed away on February 8, 1945, just twenty days short of his 100th birthday, and with him Long Island's last direct connection with the war that saved the Union.[137]

LONG ISLAND'S CONFEDERATE CONNECTIONS

Long Island may have been far from the Confederacy, but it had ties with a number of prominent Confederates:

Lieutenant Generals Robert E. Lee, Stonewall Jackson and John C. Pemberton were posted at Fort Hamilton in Brooklyn in the 1840s. Lee and Jackson were active members of St. John's Episcopal Church nearby. Jackson was baptized there on April 29, 1849, and he and Lee served as vestrymen, earning St. John's the title Church of Generals.

General John B. Gordon of Georgia was a student at Flushing Institute before attending the University of Georgia.

Brigadier General Robert S. Garnett, the first general on either side killed in the Civil War, is buried in Brooklyn's Green-Wood Cemetery. After Garnett was slain at the Battle of Corrick's Ford, Virginia (now West Virginia), on July 13, 1861, his remains were entombed in Maryland. When peace was restored, his body was brought to Green-Wood and laid to rest next to his wife and son on August 28, 1865.

Brigadier General William Henry Fitzhugh "Rooney" Lee, a son of Robert E. Lee, was the most famous of numerous Confederate officers incarcerated in Fort Lafayette in Brooklyn (see page 26). Rooney was captured after being wounded at the Battle of Brandy Station on June 9, 1863, and held at the fort from July until March 1864, when he was exchanged.

Joseph Wheeler had the unusual distinction of serving as a general in both the Confederate and United States armies. Highly respected as a cavalry officer, "Fighting Joe" Wheeler was commissioned a major general of volunteers by President

Henry Brand, Long Island's last Confederate veteran. *From the collection of Harrison Hunt.*

William McKinley at the beginning of the Spanish-American War in 1898. After commanding a cavalry division in Cuba that included Theodore Roosevelt's Rough Riders, Wheeler was assigned to oversee the army convalescent camp at Montauk Point, Camp Wikoff, where soldiers returning from Cuba were quarantined and treated for yellow fever and other diseases. Wheeler supervised the camp from August 17 until September 26, 1898, during which time the huge installation covered twenty-eight square miles and treated 29,500 men. He left to take another assignment in Alabama, probably wishing to move from the location where his seventeen-year-old son and aide, Naval Cadet Thomas Wheeler, had drowned on September 7.

The last Confederate veteran on Long Island was Henry L. Brand of Beechhurst, Queens, who died on November 20, 1936, only three weeks shy of his 100th birthday. Brand was born in Germany, came to New York as a child and was working on a Southern plantation when the war broke out.

He enlisted in the Second Florida Infantry and was captured at the Battle of Williamsburg on May 5, 1862. According to his obituary:

> *A short time after this he was sent to Washington on parole, and while there had an interesting experience with President Lincoln. Mr. Brand was only four feet ten inches tall. As President Lincoln passed* [the Confederate prisoner] *one day, he stopped, put his hand on Brand's head and said: "A mighty small soldier, but I glory in your spunk!"*

Brand subsequently moved to New York, where he operated a jewelry business.[138]

Epilogue

The Civil War may have ended a century and a half ago, but memory of the conflict is kept alive on Long Island by a cadre of history buffs. Some are involved in reenacting or discussion groups, while others pursue their individual interests in that climactic era.

The reenactors are the most visible, portraying scenarios at living history encampments and skirmishes in local parks when not traveling to faraway battlefields. Company H, 119th New York Volunteers Historical Association (www.119nysv.org), based at Old Bethpage Village Restoration, was formed in 1980 by four Nassau County employees who worked there. They wanted to reenact a Long Island Civil War unit, something no one else was doing at the time, and each member was assigned the identity of a soldier from the original Company H. Besides its living history programs, the association maintains a collection of artifacts from the original unit. It also paid for restoration of the 119th New York's monument at Gettysburg. And it led the effort to raise the $18,500 necessary in 2005 to replace the statue stolen in 1992 from Roslyn's monument to Civil War soldiers.

During a day of drilling and reenacting camp life at Old Bethpage in the fall of 2014, association members explained their motivation for enlisting. "We do this to honor the soldiers," said Bill Carman of Wantagh, sixty, a site manager for a home development company who's been reenacting for sixteen years. He portrays his ancestor, Private John Carman, a Company H teamster during the Atlanta Campaign and March to the Sea who returned to Long Island to farm in Merrick.

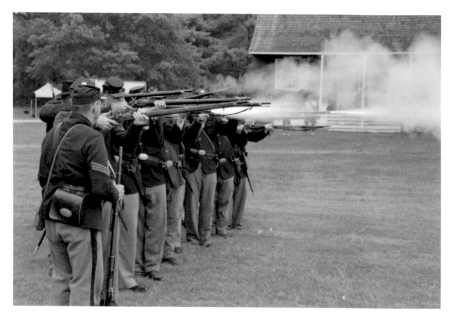

Members of the Company H, 119th New York Volunteers reenactment unit drilling at Old Bethpage Village Restoration. *Bill Bleyer photograph.*

Rob Weber of Farmingdale, fifty-five, a print manager for Sarah Lawrence College, has been reenacting for eighteen years after starting out as a Civil War antique collector, member of roundtables and painter of scenes from the conflict since childhood. Weber, who had three ancestors fighting in the war, including a Medal of Honor winner from Ohio, said that by reenacting, "I understand now a lot more what the soldiers were actually doing. And it's fun."

The Company K, 67th New York Historical Association (www. newyorkcivilwar.com), based in Sayville, was founded in 1997 to portray soldiers in the First Long Island Volunteers. Besides its living history efforts, the association has donated more than $18,000 to institutions such as the Civil War Trust to help save battlefields. The 14th Brooklyn Regiment, NYSM, Company E, Living History Association (www.14thbrooklyn.info/index.htm), formed in 1996, is also based on Long Island and, besides living history reenactments, tackles grave site restoration projects. The 88th New York State Volunteers, Company K (http://reenactor.wix.com/88th-nysv), depicts a unit from the Irish Brigade.

On the Confederate side, there is the 57th Virginia Company B, of Longstreet's Corps organization (www.57thvirginiainfantry.com); the 9th Virginia, Company

C (www.9vareenacting.com/index.html); and the 30th Virginia Infantry, Company B (www.facebook.com/30thVirginiaInfantryCompanyB).

In recent years, there have been several efforts to install or restore Civil War monuments at local burial grounds or parks. The most recent addition came with the dedication of a Farmingdale Civil War monument on the village green on Memorial Day in 2011. A monument to Medal of Honor winner William Laing of Hempstead, who served with the 158th New York Infantry, was erected at St. George's Cemetery in the village in 2008. And a memorial at Lyceum Cemetery in Bethpage in honor of Alfred Walters of Farmingdale, a soldier in the 145th and 107th New York Infantry Regiments who died of illness at Nashville, Tennessee, on January 29, 1865, was replaced by Patrick Looney in an Eagle Scout project and dedicated on August 21, 2009.

While its members don't wear uniforms or fire weapons, the twenty-year-old North Shore Civil War Roundtable (www.northshorecivilwarroundtable. org) brings history buffs together to listen to authors, tour battlefields and support preservation of important artifacts and historic sites. According to its president, Andrew Athanas, a retired teacher, the group was the idea of Richard Klein, co-owner of Book Revue in Huntington, at a time of renewed interest in the war. Cass Baker became the first president, and the bookstore helped publish a monthly newsletter, *Drumroll*, which continues to this day even though the organization has moved twice and now meets at the South Huntington Public Library. Annual battlefield tours began in 1997, and membership grew to more than one hundred. Athanas said the roundtable's mission is unchanged: "broadening our understanding of the American Civil War."

Roundtable secretary Jeffrey Richmond, a retired legal-aid attorney from Huntington, began working part time as a tour guide at Green-Wood Cemetery in Brooklyn in 2000 and later became a full-time historian there. He has written a book about some of the 3,300 Civil War soldiers and sailors buried at the landmark site and organized a project to obtain headstones for 1,200 of those graves that were not marked.

The Long Islander who has had the widest impact in keeping the Civil War in the public's view is Mort Künstler, the country's top-selling painter of American history subjects. In his six-decade career that began with illustrating men's action magazine covers, the Cove Neck resident has depicted hundreds of highly researched Civil War scenes, including several with Long Island themes—one of which can be found on the back cover of this book.

Künstler, who announced his retirement in early 2015 at age eighty-seven, said his interest in the conflict began by accident. "I didn't know anything about the Civil War," he said in an interview for this book, until 1988, when he decided to do a painting for the 125th anniversary of the Battle of Gettysburg. He visited the Pennsylvania town, wandered into an art gallery and was offered a very lucrative deal for turning his yet unpainted Pickett's Charge image, *The High Water Mark*, into prints. The reproductions sold so well that he kept going. "I love painting narrative pictures, and there was so much of the Civil War that had never been painted before," he said. "I try to open up a window on the past for people so they will say to themselves, 'Gee, I feel like I'm there.' I've made history come alive for a lot of people, and that's a thrill for me."

Appendices

MEDAL OF HONOR RECIPIENTS WITH LONG ISLAND CONNECTIONS

Beddows, Richard. Private, Thirty-fourth Independent Battery. Flushing.

Brush, George. Thirty-fourth U.S. Colored Troops. Born Huntington.

Irving, John. Coxswain, USS *Brooklyn*. Born Brooklyn.

Laing, William. Sergeant, Company F, 158th New York Volunteers. Hempstead.

Ludwig, Carl. Private, Thirty-fourth Independent Battery. College Point.

Pease, Joachim. Seaman, USS *Kearsarge*. Long Island.

Rossbach, Valentine. Sergeant, Thirty-fourth Independent Battery. Flushing.

Smith, Edwin. Seaman, USS *Whitehead*. Jamaica.

Starkins, John H. Sergeant, Thirty-fourth Independent Battery. Flushing.

Webb, James. Private, Company F, Fifth New York Infantry. Born Brooklyn.

SHIPS ON WHICH LONG ISLAND MEN SERVED

U.S. Navy

Adirondack
Ariel
Aroostook
Augusta
Brooklyn
Buckthorn
Calypso
Catskill
Cayuga
Chenango
Colorado
Connecticut
Crusader
Cyane
Ella
Ellis
Emma
Florida
Galena
Glaucus
Hartford
Heliotrope
Hunchback
Hussar
Hydrangea
Itasca
Kearsarge

Kensington
Keystone State
Lackawanna
Lehigh
Louisville
Malvern
Mary Sanford
Memphis
Merrimac
Minnesota
Mobile
Monticello
Morning Light
Mound City
Nemaha
Neptune
New Berne
New Hampshire
New Ironsides
Niagara
Norfolk
North Carolina
Northern Light
Ossipee
Owasco
Pawnee
Pensacola

Picket
Primrose
Racer
Rachel Seaman
Richmond
Roanoke
Sabine
Saco
St. Lawrence
St. Mary's
Sampson
Santee
Santiago
Savannah
Sciola
Sciota
Seminole
Seneca
Sonoma
Stars & Stripes
Susquehanna
Tallapoosa
Union
Vanderbilt
Vermont
Wabash
Whitehead

U.S. Revenue Service

Agassiz
Crawford

Naugatuck
Nemaha

GRAND ARMY OF THE REPUBLIC POSTS

(Chronologically by county, with post number, name and year organized)

Queens

Flushing, 50, George Huntsman, 1869
Long Island City, 283, Benjamin Ringgold, 1882
Jamaica, 368, Alfred M. Wood, 1883
College Point, 451, Adam Wirth, 1883
Elmhurst, 560, Robert J. Marks, 1885
Long Island City, 628, Philip H. Sheridan, 1888
Oceanus, 636, John Corning, 1892

Nassau

Oyster Bay, 365, Daniel L. Downing, 1883
Freeport, 527, D.B.P. Mott, 1884
Hempstead, 544, Moses Baldwin, 1885
Inwood, 563, Leander Monroe, 1885
Roslyn, 654, Elijah Ward, 1891

Suffolk

Riverhead, 77, Henry W. Halleck, 1872
Patchogue, 210, Richard J. Clark Jr., 1881
Sag Harbor, 274, Edwin Rose, 1882
Greenport, 353, E.F. Hunting, 1883
Northport, 426, Samuel Ackerly, 1883
Bay Shore, 538, William Gurney, 1885
Port Jefferson, 627, Lewis O. Conklin, 1888
Huntington, 641, Jacob C. Walters, 1889
Amityville, 643, Hugh B. Knickerbocker, 1889
Riverhead, 656, Henry A. Barnum, 1892

Notes

Abbreviations of newspapers and standard sources:

FJ: *Flushing Journal*
GCG: *Glen Cove Gazette*
HI: *Hempstead Inquirer*
LI: *Long-Islander*
LID: *Long Island Democrat*

LIF: *Long Island Farmer*
LIT: *Long Island Times*
QCS: *Queens County Sentinel*
SHC: *Sag Harbor Corrector*

If not specifically cited, general information has been taken from the newspapers given above.

Lists of servicemen have been compiled from the service records printed in Munsell's *History of Queens County* and *History of Suffolk County*, government records and rosters in local newspapers.

CHAPTER 1

1. Map of routes, Wilber Siebert, *The Underground Railroad from Slavery to Freedom* (New York: MacMillan, 1897); Velsor, *Angel of Deliverance*, 60; Vahey, "Hidden History," 33; Marietta Hicks, "Old Westbury and Jericho A Closely-knit Quaker Community" (typescript, undated).

2. William Jagger, *Information Acquired from the Best Authority, With Respect to the Institution of Slavery* (New York: R. Craighead, 1856).

3. *GCG*, June 16, 1860; *HI*, June 29, 1860.

4. *GCG*, June 23, 1860; *LI*, June 29, 1860; *Suffolk Democrat*, July 13, 1860; *SHC*, September 1, 1860.

5. *GCG*, July 27, 1860; *FJ*, August 4, 1860; *GCG*, September 1, 1860; Bleyer, "Society Buys"; *GCG*, September 20, 1860.

6. *GCG*, September 8, 1860; *LID*, October 23, 1860.

7. *SHC*, October 6, 1860; *LID*, October 6, November 2, 1860; *SHC*, November 3, 1860.

8. *LID*, November 6, 1860; Osborn, "Queens County," 132–45; Hunt, "Suffolk County," 3–16.

9. *LI*, November 23, 1860; *SHC*, November 10, 1860; Hunt, "East Hampton," 323–31; *GCG*, November 10, 1860; *HI*, November 10, 1860.

10. *HI*, November 17, 1860; *FJ*, December 15, 1860.

11. *LI*, January 11, 1861; *SHC*, January 12, 1861; *LI*, January 18, 1861.

12. *GCG*, January 19, 1861; *SHC*, February 23, 1861.

13. Charles H. Brown, *William Cullen Bryant* (New York: Scribner's, 1971).

CHAPTER 2

14. *GCG*, April 20,1861; *LI*, April 19,1861.

15. *SHC*, April 27,1861.

16. *LID*, July 16,1861

17. Gates, "Nassau County," 8–9; *SHC*, April 27, May 18, 1861; *LI*, April 26, 1861.

18. *LI*, April 26, 1861; *SHC*, April 27, 1861.

19. *Brooklyn Eagle*, July 6, 1861.

20. Munsell, service lists; Edgar Jackson tombstone, Jackson cemetery, Wantagh.

21. *SHC*, August 31, 1861; Bleyer, "Rallying to the Union," *Newsday*, April 3, 2011; *New York Times*, September 7, 1861; *FJ*, August 31, 1861; *LIT*, September 5, 1861.

22. *HI*, August 10, 17, 1861; *GCG*, August 3, 1861.

23. Bethauser, "Henry A. Reeves," 34–43; Lucius Hallock, letter, March 19, 1933, Historic Hallockville files.

24. *SHC*, May 25, 1861; Mary Walker to Henry Smith, Smithtown Historical Society.

25. *QCS*, September 12, 1861.
26. *New York Times*, September 12, 13, 1861; *Long Island Times*, undated clipping, Archives, Queens Borough Public Library.

Chapter 3

27. Bleyer, "Rallying to the Union."
28. *FJ*, May 18, 1861, September 6, 1862; Hammond, *Civil War Records*.
29. *LI*, January 1862; Hallock, "Desertion," 124.
30. *LI*, July 4, 1862; Duganne, *Fighting Quakers*; Hammond, *Oyster Bay*.
31. Hunt, "Queens Perspective"; Phisterer, *New York*; *SHC*, June 1, 1861; *FJ*, July 6, 1861.
32. Hunt, "East Hampton," 328; *New York Times*, June 7, 1914.
33. Homan, "Civil War Recollections."
34. Unless otherwise noted, all regimental histories are taken from Phisterer, *New York*, or *The Union Army: A History of Military Affairs in the Loyal States, 1861–65* (Madison, WI: Federal Pub. Co., 1908), vol. 2.
35. Tevis and Marquis, *History of the Fighting Fourteenth*; William Fox, *New York at Gettysburg* (Albany, NY: J.B. Lyon, 1902); *SHC*, September 20, 1862.
36. DeWan, "Fighting Zouaves."
37. Homan, "Civil War Recollections," 76–81, 106–14.
38. Hunt, "Suffolk County"; *Brooklyn Eagle*, August 7, 1863; "The Seven Days' Fight," *The Arkansas Traveller Songbook* (New York: Dick & Fitzgerald, 1864), 15.
39. Hunt, "'Captain Quarterman's Company,'" 1–14; Thomas S. Townsend, *The Honors of the Empire State in the War of the Rebellion* (New York: A. Lovell & Co., 1889), 133; Hammond, *Civil War Records*.
40. Gates, "Nassau County," 2–7; Wick, "Long Island Marches," 198–201.
41. John Henry Young Papers, Oysterponds Historical Society; Prince, *Civil War Letters*, 41, 61; Hammond, *Oyster Bay*, 210–12.
42. Bayles, *Civil War Letters*.
43. *LID*, August 26, 1862.
44. *LID*, November 25, 1862.
45. *FJ*, August 30, 1862; *LI*, August 22, 1862; Hammond, *Oyster Bay*; Hammond, *Civil War Records*; Daniel Isaac Underhill Letters, Oyster Bay Historical Society.
46. Walter, "Song of a Civil War Veteran," 48–52.

47. Roemer, *Reminiscences*, 303; "34th Independent Battery," New York State Military Museum and Veterans Research Center, http://dmna. ny.gov/historic/reghist/civil/artillery/34thIndBat/34thIndBat_Report_ Roemer.htm.

48. J.J.A. Morgan, "A Sermon in Memory of Joseph and Dandridge B.P. Mott," 14–15 (Hempstead, NY: Queens County Sentinel, 1865).

49. Geoffrey K. Fleming, "A Sharpshooter from Southold," 2004; *LID*, August 20, 1861; Hunt, "Queens Perspective."

50. Bleyer, "Bringing the Civil War."

CHAPTER 4

51. Ross, *History of Long Island*, vol. 3, *Suffolk*, 154–55; Barbara Delatiner, "Glen Cove Steamer in Book and Painting," *New York Times*, April 27, 2003.

52. Horton, "Slave Ship *Wanderer*," 83–84, 97–98; Cassese, "Memorializing."

53. *Brooklyn Evening Star*, August 3, 1862; Ross, *History of Long Island*, vol. 3, *Suffolk*, 85, 291, 338; *QCS*, August 1, 1861; *SHC*, July 28, 1864; Hunt, "East Hampton," 329.

54. Hunt, "Suffolk County," 11; *SHC*, May 1, 1862; Ross, *History of Long Island*, vol. 3, *Suffolk*, 154–55, 215; Irene Hallock Dickinson, "Capt. 'Lant' of Rocky Point," *Long Island Forum* 35 (November 1972): 245.

55. Livingston, *Brooklyn and the Civil War*, 69; Dean Barron, "Huntington Town's Paulding," *Long Island Heritage* (October 1984).

56. Livingston, *Brooklyn and the Civil War*, 75–76; *FJ*, March 15, 1862; Tony Gibbons, *Warships and Naval Battles of the Civil War* (New York: Gallery Books, 1989), 26–27.

57. Munsell, service lists; Phisterer, *New York*, 1:455.

58. Munsell, service lists; Scott Simms, "Sinking of the Picket," *Sag Harbor Express*, www.sagharboronline.com/sagharborexpress/xtras/sinking-of-the-picket-19456.

59. Florence Kern, *The United States Revenue Cutters in the Civil War* (Bethesda, MD: Alised, 1990), 13.4–13.5; George Von Skal, *Illustrated History of the Borough of Queens* (New York: F.T. Smiley, 1908), 23–24.

CHAPTER 5

60. Horton, "Slave Ship *Wanderer*," 84.

61. *Harper's Weekly*, August 3, 1861; *Scientific American*, August 3, 1861.

62. Abraham Lincoln, letter to Horace Greeley, August 22, 1862.

63. Joseph H. Reidy, "Black Men in Navy Blue During the Civil War," *Prologue Magazine* 33 (Fall 2001); Phisterer, *New York*, 5:455.

64. *LIF*, March 17, 1863; Gladstone, *Men of Color*; Hunt, "'Many Thousand Gone.'"

65. Hunt, "'Many Thousand Gone'"; Hammond, *Civil War Records*.

66. Munsell, service lists; Harry Bradshaw Matthews, *Honoring New York's Forgotten Soldiers: African Americans of the Civil War* (Oneonta, NY: Hartwick College, 1998); Hunt, "'Many Thousand Gone.'"

67. *SHC*, December 26, 1863.

68. Munsell, service lists; Amy Webster, "Capt. George Washington Brush, M.D." (Huntington, NY: Town Historian's Office, 1998).

CHAPTER 6

69. *GCG*, September 21, 1861; *LI*, December 6, 1861.

70. *LID*, December 10, 1861; *LI*, January 17, 1862; *FJ*, August 9, 1862.

71. *LIF*, June 30, 1863; *Report of the Ladies' Soldier's Aid Association of Glen Cove* (Glen Cove, NY: Glen Cove Gazette, 1862), 5–6; *GCG*, August 9, 1862; *Brooklyn and Long Island Sanitary Fair*, 173–87.

72. *LIF*, December 1, 1863; *LIT*, June 8, 1865; MacMaster, "Fort Totten," 21; *GCG*, December 17, 1864; *GCG*, July 12, 1862; Kenneth Cornwall, "Cornwallton," *Cow Neck Peninsula Historical Society Journal* (October 1976): 59–60.

73. Mary Douglass clippings, Long Island Collection, Queens Borough Library; Smith, *Reminiscences*; Dorothy Zaykowski, *Sag Harbor: An American Beauty* (Sag Harbor, NY: Sag Harbor Historical Society), 365.

74. *Port Jefferson's Foremost Painter W.M. Davis* (Historical Society of Greater Port Jefferson, 1973); Bloodgood H. Cutter, *The Long Island Farmer's Poems* (New York: Tibbals, 1886), 287.

75. L. Beecher Homan, *Yaphank As It Is* (New York: J. Polhemus, 1875), 112–13; George L. Weeks, *250 Years in Bay Shore and Brightwaters* (Islip, NY: n.p., 1958), 24; *Census of the State of New York*, 734–35.

76. Jeanette Rattray, *Montauk: Three Centuries of Romance, Sport and Adventure* (East Hampton, NY: The Star Press, 1938); *Census of the State of New York*, 326, 350, 374, 399, 400, 404; Hunt, "East Hampton," 330.
77. Charlotte Merriman notebook, Cow Neck Peninsula Historical Society; Edna Yeager, *Peconic River Mills and Industries* (Riverhead, NY: Suffolk County Historical Society, 1965), 17; *LI*, July 5, 1861; Hunt, "Queens Perspective"; Haas, "Conrad Poppenhusen," 135–44; Gates, "Nassau County," 9; *LIF*, August 30, 1864.
78. Hunt, "East Hampton," 330.
79. Dennis Worthen and Greg Higby, *Medicines for the Union Army* (London: Routledge, 2001); Livingston, *Brooklyn and the Civil War*, 64–66.
80. Morris, *Better Angel*; Ed Folsom and Kenneth M. Price, eds., The Walt Whitman Archive, www.whitmanarchive.org; Edwin H. Miller, ed., *Walt Whitman: The Correspondence* (New York: New York University Press, 1961), 1:135; 1890 Special Census of Veterans.

CHAPTER 7

81. Tevis and Marquis, *History of the Fighting Fourteenth*.
82. Gates, "Nassau County"; Henry Camps service record.
83. Fox, *New York at Gettysburg*.
84. Hunt, "Captain Quarterman's Company"; Fox, *New York at Gettysburg*; *FJ*, July 11, 1863.
85. Roemer, *Reminiscences*, 117–24.
86. Hunt, "Rally Round the Flag"; Haas, "Conrad Poppenhusen"; Hallock, "Desertion."
87. Hunt, "New York State Militia"; Barnet Schecter, *The Devil's Own Work* (New York: Walker, 2005).
88. Steve Wick, "Caught Up In Anti-Draft Riots," in *Long Island Our Story*, 203.
89. Southampton Town Records, 7:501; Hunt, "Suffolk County," 12; William Cullen Bryant II and Thomas Voss, eds., *Letters of William Cullen Bryant* (n.p., n.d.), 4:320; Henry Weisberg and Lisa Donneson, *Guide to Sag Harbor* (Sag Harbor, NY: John Street Press, 1975), 78–79; Hunt, "Queens Perspective."
90. Henry Onderdonk Jr., *History of the First Reformed Dutch Church of Jamaica, L.I.* (Jamaica, NY: The Consistory, 1884), 132–33; *LID*, July 21, 1863; Hunt, "New York State Militia," 108.

91. Suffolk County Court records, file 694, 150–54; *Sag Harbor Express*, March 30, 1865; *New York Evening Post*, February 13, 1865. We are indebted to Ned Smith for this information.

92. *SHC*, June 3, 1865; Munsell, *Queens County*, 65; Bleyer, "Rallying to the Union"; *SHC*, May 27, 1865; *QCS*, December 29, 1864; Hammond, *Civil War Records*.

93. *FJ*, July 11, 1863.

94. C.C. Hewitt, "Nineteenth Regiment of Infantry," U.S. Army Center of Military History, www.history.army.mil/books/R&H/R&H-19IN.htm; Jody Revenson, "Delancey Floyd-Jones," Findagrave.com.

Chapter 8

95. Elisha Wells Papers, Suffolk County Historical Society.

96. Hammond, *Oyster Bay*, 334; Brownell, *At Andersonville*.

97. *SHC*, May 14, 1864.

98. Bayles, *Civil War Letters*.

99. *SHC*, June 4, 1864.

100. Hunt, "Suffolk County"; Hunt, "New York State Militia," 108.

101. *HI*, July 2, 1864.

102. *SHC*, July 23, 1864.

103. Hunt, "East Hampton"; *LID*, August 9, 1864.

104. Osborn, "Western Long Island."

105. *SHC*, September 3, 17, 1864.

106. *HI*, September 3, 10, 24, 1864; *LID*, October 4, 1864.

107. *HI*, November 5, 1864.

108. Osborn, "Western Long Island"; Hunt, "Suffolk County"; *HI*, November 12, 1864; Prince, *Civil War Letters*, 26, 115.

109. McGrath, *Monitors*; *Suffolk Weekly Times*, December 29, 1864.

110. *SHC*, December 31, 1864.

Chapter 9

111. *LI*, February 17, 1865.

112. McGrath, *Monitors*, 155–57.

113. *LI*, July 21, 1865.

114. *SHC*, March 4, 1865.

115. *LID*, March 14, 1865; *LI*, March 17, 1865.

116. *HI*, April 15, 1865.

117. *LI*, April 14, 1865.

118. *LID*, April 18, 1865; *SHC*, April 22, 1865; *HI*, April 22, 1865.

119. Champ Clark, *The Civil War: The Assassination* (Alexandria, VA: Time-Life Books, 1987), 104, 107.

120. *LID*, May 16, 1865.

121. Charles E. Squires, clipping from *East Hampton Star*, May 21, 1998, Suffolk County Historical Society.

122. *SHC*, July 1, 1865.

123. *LID*, July 4, 11, 1865.

124. *HI*, July 8, 1865.

125. *LI*, August 11, 1865.

126. *Suffolk County Press*, August 9, 1865; McGrath, *Monitors*, 62.

127. Frank Decker, *Brooklyn's Plymouth Church in the Civil War* (Charleston, SC: The History Press, 2013), 95–96; *SHC*, May 18, 1861; Robert Friedrich, "Lincoln's L.I. Cabin," *Long Island Forum* 20 (June 1957): 110–11.

CHAPTER 10

128. "Cypress Hills National Cemetery," U.S. Department of Veterans Affairs, www.cem.va.gov/cems/nchp/cypresshills.asp; Walter J. Hutter, et al., *Our Community, Its History and People* (Ridgewood, NY: Greater Ridgewood Historical Society, 1976), 233; *Harper's Weekly*, June 20, 1868.

129. *Fifth Annual Report of the Bureau of Military Statistics* (Albany, NY: O. Van Benthuysen and Sons, 1868), 16; *LID*, August 16, 1864; *New York Times*, February 20, 1865, January 24, 1870, December 27, 1871.

130. *LI*, June 24, 1864; handbill for Soldiers' Monument Association fundraising concert, February 3, 1865, Archives, Queens Borough Public Library.

131. Unless otherwise noted, information about memorials is based on visits to the sites.

132. Errol Cockfield Jr., "Old Soldier Who Faded Away," *Newsday*, February 3, 1999; Joe Scotchie, "Roslyn Civil War Statue Stands Again," *Roslyn News*, September 22, 2005.

133. *Brooklyn Daily*, "Salem Fields Memorial—Tall Salute to Fallen Heroes," www.brooklyndaily.com/stories/2008/25/bay_news_newssalemfield06162008.html; inscription, Northport Civil War memorial.

134. Ezra Warner, *Generals in Blue* (Baton Rouge: Louisiana State University Press, 1964); Richard Winsche, "General Joseph Hooker's Long Island Years, 1874–1879," *Nassau County Historical Society Journal* 62 (2007): 22–29; Barron, "Paulding."

135. Ross, *History of Long Island*, 1: 677; *Brooklyn Daily Eagle Almanac for 1898*, 172; Hunt, "Johnny."

136. Fox, *New York at Gettysburg*.

137. Hunt, "Suffolk County"; Hunt, "Johnny"; *New York Times*, February 9, 1945; "Daniel Harris Rites Monday," unidentified clipping, February 9, 1945.

138. Henry Brand obituary, unidentified clipping, November 21, 1936.

Bibliography

BOOKS AND PAMPHLETS

Bayles, Donald M. *The Civil War Letters of Albert and Edward Bayles*. Middle Island, NY: Longwood Society for Historical Preservation, 2004.

Brouwer, Norman. *A History of Fort Totten*. Bayside, NY: Bayside Historical Society, 1996.

Brownell, Josiah C. *At Andersonville*. Glen Cove, NY: Gazette Office Printing Shop, 1867. Reprinted Glen Cove Public Library, 1981.

Clemens, David, and Reginald H. Metcalf Jr. *Mustering and Parading—Two Hundred Years of Militia on Long Island, 1653–1868*. Edited by David Clemens and Harrison Hunt. Huntington, NY: Huntington Historical Society, 1982.

Copp, Elbridge. *Reminiscences of the War of the Rebellion, 1861–1865*. Nashua, NH: Telegraph Publishing Co., n.d.

Davenport, Alfred. *Camp and Field Life of the Fifth New York Volunteer Infantry (Duryée Zouaves)*. New York: Dick and Fitzgerald, 1879. Reprinted Gaithersburg, MD, 1985.

DeForest, Bartholomew S. *Random Sketches...With a Historical Sketch of the Second Oswego Regiment (81ˢᵗ New York Volunteers)*. Albany, NY: Avery Herrick, 1866.

Duganne, Augustine J.H. *The Fighting Quakers*. New York: 1869.

Gladstone, William A. *Men of Color*. Gettysburg, PA: Thomas, 1993.

Glicksberg, Charles I., ed. *Walt Whitman and the Civil War*. New York: A.S. Barnes & Co., 1963.

Hammond, John E. *Civil War Records: Town of Oyster Bay*. Oyster Bay, NY: Town of Oyster Bay, 2011.

———. *Oyster Bay Remembered*. Huntington, NY: Maple Hill Press, 2002.

Hazleton, Henry I. *The Boroughs of Brooklyn and Queens, Counties of Nassau and Suffolk Long Island, New York, 1609–1924*. New York: Lewis Historical Publishing Co., 1925.

History of Queens County, New York. New York: W.W. Munsell and Co., 1882.

History of Suffolk County, New York. New York: W.W. Munsell and Co., 1882.

History of the Brooklyn and Long Island Fair in Aid of the U.S. Sanitary Commission. Brooklyn, NY: The Union Steam Presses, 1864.

History of the Second Battalion, Duryée Zouaves, 165ᵗʰ New York Volunteer Infantry. New York: DeBaum, 1905.

Livingston, E.A. *Brooklyn and the Civil War*. Charleston, SC: The History Press, 2012.

Lowenfels, Walter, ed. *Walt Whitman's Civil War*. New York: Alfred A. Knopf, 1960.

Matthews, Harry Bradshaw. *Honoring New York's Forgotten Soldiers: African Americans of the Civil War*. Oneonta, NY: Hartwick College, 1998.

McGrath, Franklin. *The History of the 127ᵗʰ New York Volunteers, "Monitors," in the War for the Preservation of the Union*. N.p., [1898?]. Reprinted Mattituck, NY: Amereon House, 1992.

Moore, Gilbert C., Jr., ed. *Cornie, Civil War Letters of Lt. Cornelius L. Moore 1861–1864*. Chattanooga, TN: self-published, 1988.

Morris, Roy, Jr. *The Better Angel: Walt Whitman in the Civil War*. New York: Oxford University Press, 2000.

Nichols, James M. *Perry's Saints; or, the Fighting Parson's Regiment in the War of the Rebellion*. Boston: D. Lothrop, 1886.

Palmer, Abraham J. *The History of the 48ᵗʰ Regiment, New York State Volunteers, in the War of the Rebellion, 1861 to 1865*. 3ʳᵈ edition. Albany, NY: J.B. Lyon and Co., 1912.

Phisterer, Frederick, comp. *New York in the War of the Rebellion, 1861 to 1865*. 3ʳᵈ edition. Albany, NY: J.B. Lyon and Co., 1912.

Prince, Helen Wright, comp. *Civil War Letters and Diary of Henry W. Prince, 1862–1865*. N.p., 1979.

Roemer, Jacob. *Reminiscences of the War of the Rebellion*. Flushing, NY: Estate of Jacob Roemer, n.d.

Roper, Robert. *Now the Drum of War: Walt Whitman and His Brothers in the Civil War*. New York: Walker, 2008.

Ross, Peter. *History of Long Island*. New York: Lewis Publishing, 1902.

Smith, Adelaide W. *Reminiscences of an Army Nurse During the Civil War*. New York: Greaves Publishing Co., 1911.

Stiles, Henry R. *History of the County of Kings*. Albany, NY: 1884.

Tevis, Charles V., and Don Marquis. *The History of the Fighting Fourteenth*. Brooklyn, NY: Brooklyn Daily Eagle Press, 1911.

Vahey, Mary. *A Hidden History: Slavery, Abolition and the Underground Railroad in Cow Neck and on Long Island.* Port Washington, NY: Cow Neck Peninsula Historical Society, 1998.

Velsor, Kathleen G. *Angel of Deliverance: The Underground Railroad in Queens, Long Island.* Flushing, NY: Queens Historical Society, 1999.

————. *Friends of Freedom: The Underground Railroad in Queens, Long Island and Beyond.* Flushing, NY: Queens Historical Society, 2006.

————. *The Underground Railroad on Long Island.* Charleston, SC: The History Press, 2013.

Whitman, George W. *Civil War Letters of George Washington Whitman.* Durham, NC: Duke University Press, 1975.

Whitman, Walt. *Memoranda During the War.* Camden, NJ: 1875–1876. Reprinted Bloomington: Indiana University Press, 1962.

————. *Notebooks and Unpublished Prose Manuscripts, Vol. II: Washington.* Edited by Edward Grier. New York: New York University Press, 1984.

————. *The Wound Dresser.* Boston: Small, Maynard and Co., 1898. Reprinted New York: Bodley Press, 1949.

ARTICLES

Baker, C. Dwight. "A Civil War Soldier's Record." *Long Island Forum* 28 (1965): 157–58.

Bethauser, Margaret O'Connor. "Henry A. Reeves: The Career of a Conservative Democratic Editor, 1858–1916." *Journal of Long Island History* 9 (Spring 1973): 34–43.

Bleyer, Bill. "Bringing the Civil War to LI. Society Purchases Memorabilia that Belonged to a Cavalryman Who Was at Gettysburg, Ford's Theatre." *Newsday,* November 7, 2005.

———. "Rallying to the Union; For Long Islanders, Interest in Civil War Began Only After the First Shots Were Fired." *Newsday*, April 3, 2011.

———. "Society Buys Rare 1860 Wide Awakes Banner." *Civil War News* October 2014.

———. "When the Civil War Came Home to LI." *Newsday*, February 11, 2005.

Cassese, Sid. "Memorializing a Time of Shame." *Newsday*, March 13, 1986.

Conway, Richard. "Letters from a Union Soldier." *Long Island Forum* 40 (1977): 160–61.

Cory, David M. "Brooklyn and the Civil War." *Journal of Long Island History* 2 (Spring 1962): 1–15.

———. "A Brooklyn Soldier a Century Ago." *Journal of Long Island History* 3 (Fall 1963): 1–30 and 4 (Summer 1964): 1–27.

———. "The Friel Civil War Letters." *Journal of Long Island History* 5 (Winter 1965): 18–26.

DeWan, George. "The Fighting Zouaves: A Port Jefferson Boy Joins the 'Zoo-Zoos,' the Best-Dressed Soldiers in the Civil War." *Newsday*, January 12, 1999.

Finckenor, George. "Hunted by Confederate Raiders." *Long Island Forum* 55 (Fall 1993): 34–41.

"Four Civil War Letters…A Hundred Years After." *Nassau County Historical Society Journal* 24 (Summer 1964): 12–24.

Gates, Arnold. "Nassau County in the Civil War." *Nassau County Historical Society Journal* 24 (Winter 1963): 1–11; reprinted by the author, 1964.

Gibbs, Iris, and Alonzo Gibbs. "Sermons in Stone." *Long Island Forum* 23 (1960): 77.

Gilmartin, Richard T. "U.S.S. *Montauk.*" *Long Island Forum* 26 (1963): 77–78.

Haas, James E. "Conrad Poppenhusen: A Biographical Sketch of the 'Benefactor of College Point' Emphasizing the Civil War Years." *Long Island Historical Journal* 16 (Fall 2003/Spring 2004): 135–44.

Hallock, Judith Lee. "Desertion and Perseverance in Suffolk County's Civil War Soldiers." *Suffolk County Historical Society Register* 28 (November 2012): 28–43.

———. "The Role of the Community in Civil War Desertion." *Civil War History* 29 (1983): 123–34.

Hathaway, Horace. "General Francis B. Spinola." *Long Island Forum* 9 (1946): 166.

Homan, John Gilbert. "Civil War Recollections." *Long Island Forum* 41 (1978): 76–81, 106–14.

Horton, H.P. "The Slave Ship *Wanderer.*" *Long Island Forum* 8 (May 1945): 83–84, 97–98.

Hunt, Harrison. "'Captain Quarterman's Company': Company C, Fifth Excelsior Brigade in the Civil War." *Nassau County Historical Society Journal* 68 (2013): 1–14.

———. "East Hampton and the Civil War." In *Awakening the Past*, edited by Tom Twomey. New York: Newmarket Press, 1999, 323–31.

———. "Rally Round the Flag" liner notes. Old Bethpage, NY: Friends for Long Island's Heritage, 1989.

———. "Suffolk County and the Civil War: An Overview." *Suffolk County Historical Society Register* 28 (November 2012): 3–16.

———. "When Johnny Came Marching Home: Nassau County's Grand Army of the Republic Posts and Civil War Memorials." *Nassau County Historical Society Journal* 50 (1995): 24–29.

Lott, Roy E. "Huntington Civil War Co. E." *Long Island Forum* 22 (1959): 153–55.

MacMaster, Richard K. "Fort Totten and the Civil War." *Long Island Forum* 26 (1963): 3–4, 20–22.

———. "Richard C. McCormick of Jamaica." *Long Island Forum* 25 (1962): 259–66.

Osborn, David. "Queens County and the Secession Crisis." *Long Island Historical Journal* 5 (Spring 1993): 132–45.

———. "Western Long Island and the Civil War: A Political Chronicle." *Long Island Historical Journal* 7 (Fall 1994): 86–98.

Overton, Marion. "The Brooklyn Home Front in 1862." *Long Island Forum* 10 (1947): 223–24, 237.

"A Prominent Roslynite." *Long Island Forum* 21 (1958): 38.

Schneider, Louis H. "College Point and the Civil War." *Long Island Forum* 26 (1963): 184, 193–94.

Seyfried, Vincent. "The Civil War in Queens County." *Long Island Historical Journal* 5 (Spring 1993): 146–56.

Simms, Scott. "Sinking of the *Picket*." [2012] www.sagharboronline.com/sagharborexpress/xtras/sinking-of-thepicket-19456.

Smith, Mrs. Irwin. "Camp Winfield Scott." *Nassau County Historical Society Journal* 25 (Fall–Winter 1964–1965): 43–50.

Smith, Renville S. "Brooklyn's Fighting 14th Regiment." *Long Island Forum* 9 (1946): 213, 216.

Smits, Edward J., and Arthur Beltrone Jr. "Army Life for the Long Island Soldier." *Nassau County Historical Society Journal* 24 (Winter 1963): 12–18.

Speierl, Charles F. "Patchogue's Kansas Brigade." *Long Island Forum* 34 (1971): 242–46, 260–62.

Stryker-Rodda, Harriet M. "The Brooklyn and Long Island Sanitary Fair, 1864." *Journal of Long Island History* 4 (Winter 1964): 1–17.

Tooker, James E. "Famous Long Island Warship." *Long Island Forum* 11 (1948): 88, 90–91.

Tooker, John. "Islip's Civil War Hero." *Long Island Forum* 19 (1956): 89, 94.

———. "Melancton Smith, Naval Hero." *Long Island Forum* 17 (1954): 83–84, 97.

Van Santvoord, Peter L. "The Civil War Comes to Glen Cove." *Long Island Forum* 24 (1961): 151–52.

Walter, Helen P. "Song of a Civil War Veteran." *Long Island Forum* 45 (1982): 48–52.

Wick, Steve. "Long Island Marches Off to Battle." *Long Island Our Story. Newsday*: 1998, 198–201.

———. "One Soldier's Story: A Farm Boy's Letters Bring History to Life." *Newsday*, May 25, 1997.

Wilson, Paul V. "Benjamin Willis and Company 'H.'" *Long Island Forum* 31 (1968): 54–55.

Winsche, Richard. "General Joseph Hooker's Long Island Years, 1874–1879." *Nassau County Historical Society Journal* 62 (2007): 22–29.

Wood, Clarence A. "General Woodford, Long Islander." *Long Island Forum* 15 (1952): 225–26.

———. "Sidney Ritch, Singing Soldier." *Long Island Forum* 15 (1952): 183–84, 193.

GOVERNMENT RECORDS

Census of the State of New York for 1865. Albany, NY: Charles Van Benthuysen, 1867.

Complete Record, as Required by Chapter 690, of the Laws of 1865, Relating to Officers, Soldiers and Seamen…Furnished to the United States…in the War of the Rebellion. Newtown, Hempstead, North Hempstead, Oyster Bay, Huntington, Brookhaven, Riverhead, Southampton, East Hampton and Southold.

New York State Adjutant General's Office. *Registers of the New York Regiments in the War of the Rebellion.* Albany, NY: 1893–1905.

Town Records of Hempstead, North Hempstead, Oyster Bay, Huntington, Smithtown, Riverhead, Southampton, East Hampton, Southold and Shelter Island.

CIVIL WAR PERIOD NEWSPAPERS

Brooklyn Daily Eagle
Brooklyn Daily Times
Corrector
Flushing Journal
Glen Cove Gazette
Hempstead Inquirer
Long Island Democrat
Long-Islander
Long Island Farmer
Long Island Times
Queens County Sentinel
Republican Watchman
Sag Harbor Express

Manuscripts

Fleming, Geoffrey K. "A Sharpshooter from Southold," 2004.

Hunt, Harrison. "The Civil War: A Queens Perspective." Exhibit script, Queens Historical Society, Flushing, 1993.

————."'Many Thousand Gone': Long Island African Americans and the Civil War." Exhibit script, African American Museum, Hempstead, 1993.

————. "The New York State Militia on Long Island, 1828–1860." MA thesis, Cooperstown Graduate Program, 1985.

Seyfried, Vincent. "Newtown in the Civil War." Unpublished manuscript, n.d.

————. Notes on Civil War items in the *Long Island Farmer*.

Underhill, Daniel Isaac. Papers. Oyster Bay Historical Society.

Wells, Elisha. Papers. Suffolk County Historical Society.

Young, John Henry. Papers. Oysterponds Historical Society.

Index

About the Authors

Harrison Hunt, who has researched Long Island's role in the Civil War for more than twenty years, has written two other books about the conflict: *Hallowed Ground*, an overview of seventeen key battles, and *Heroes of the Civil War*, brief biographies of seventy wartime figures. Hunt has explored the topic at numerous historical societies, libraries and Civil War Roundtables; written several articles on the subject; and curated two major exhibits about Long Islanders and the war. He has led tours of the Gettysburg battlefield, given presentations about military history at the New-

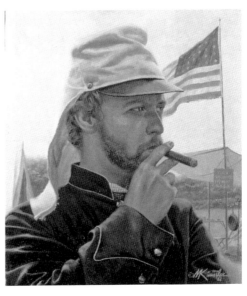

Private Harrison Hunt, 119th Regiment, N.Y.S.V., by Mort Künstler. © *1982 Mort Künstler, Inc.*

York Historical Society and Gettysburg National Military Park and served as a consultant to the noted Civil War artist Mort Künstler, whose portrait of Hunt is seen on this page.

Before his retirement, Hunt was the senior curator of history and supervisor of historic sites for the Nassau County Department of Parks. He holds a BA in history from Hofstra University and an MA in history museum studies from the Cooperstown Graduate Program, where he was a National Museum Act Fellow. He lives in a Civil War–vintage house in Catskill, New York, with his wife, Linda.

Bill Bleyer was a prize-winning *Newsday* staff writer for thirty-three years before retiring in the summer of 2014 to work on this book and write freelance articles. The Long Island native has written extensively about history for *Newsday* and magazines. In 1999–2000, he was one of four *Newsday* staff writers assigned full time to "Long Island: Our Story," a yearlong daily history of Long Island that resulted in three books and filled hundreds of pages in the newspaper.

Bill Bleyer by Mort Künstler. © 2014 Mort Künstler, Inc.

The author of a chapter in the anthology *Harbor Voices: New York Harbor Tugs, Ferries, People, Places and More* published in 2008, Bleyer also was a contributor and editor of the Bayville history book published by Arcadia in 2009.

His work has been published in *Civil War News, Naval History, Sea History, Lighthouse Digest* and numerous other magazines and in the *New York Times, Chicago Sun-Times,* the *Toronto Star* and other newspapers. Prior to joining *Newsday,* Bleyer worked for six years at the *Courier-News* in Bridgewater, New Jersey, as an editor and reporter. He began his career as editor of the *Oyster Bay Guardian* for a year.

Bleyer graduated Phi Beta Kappa with highest honors in economics from Hofstra University, where he has been an adjunct professor teaching journalism and economics. He earned a master's in urban studies at Queens College of the City University of New York. He lives in Bayville, New York.